CW00504323

PUBLIC VIEW

A Profile of The Royal West of England Academy

PUBLIC VIEW

A Profile of The Royal West of England Academy

David Bethell

John Hudson

Timothy Mowl

Helen Reid

John Sansom

Sheena Stoddard

Ed. John Sansom

First published in 2002 by Redcliffe Press Ltd.,
81g Pembroke Road, Bristol BS8 3EA.

copyright text: the authors
this collection: Redcliffe Press Ltd
copyright illustrated work: the artists

It has not always been possible to obtain consent for reproductions;
that of current Academicians has been assumed. Any queries regarding copyright should be
addressed to the publishers.

ISBN 1 900178 04 4

British Library Cataloguing-in-Publication Data
A catalogue record for this book is available from the British Library.

Designed by Stephen Morris, smc@freeuk.com, Liverpool and Bristol

Printed by HSW Print, Tonypandy, Rhondda

Contents

Publisher's note

T he word 'profile' in this book's sub-title gives the clue. *Public View* is not a blow-by-blow account of the history of what started as the Bristol Academy for the Promotion of the Fine Arts and since 1913 has been honoured with royal status. In a history running back just short of 160 years, the Academy has had its spells in the doldrums when, viewed in hindsight, nothing very much seems to have happened, just as in that time there have been high spots of drama and controversy. Our intention has been to encapsulate the essence of a great institution which, despite its ups and downs, has entered the twenty-first century in great heart, poised to realise its tantalising potential, to serve not only as a vibrant centre of cultural activity in Bristol but also as one of the country's premier exhibiting venues. The result, I hope, is a story that will fire the imagination, while providing a valuable reference source for art historians.

We must thank Dr David Bethell for his research and a typescript which, along with the late Donald Milner's 'Essay in Patronage', has formed the bedrock of this work; both have prompted more detailed research. We have been fortunate to have Dr Timothy Mowl writing on the architecture of the building and Sheena Stoddard on the remarkable Sharples family without whom, it can be persuasively argued, we would not have an academy in its present form. Sheena Stoddard and Bristol Museums and Art Gallery are also to be thanked for the loan of transparencies and prints. The story has been given added colour by Helen Reid's research into the extent of Wills family patronage, with the counterpoint of John Hudson's profile of Lord Methuen, a 'hands-on' president who galvanised an enfeebled Academy in the crucial post-1939/45 years. Karin Walton's history of the first 75 years of Bristol Art Gallery has been a valuable reference. Anthony Beeson, Art Librarian at the Bristol Central Reference Library, kindly provided information on Maria Spilsbury.

For their help with the history of the building, we thank Brian Earnshaw, Anthony Beeson, David Gould, Jo Hibbert (Acanthus Ferguson Mann) and Robert O'Leary.

Dr Paul Gough, Dean of the Faculty of Art, Media and Design at the University of the

West of England, Bristol, provided much needed help with the chapter on the Academy's role in art education, and Judith Greenbury's and Francis Hewlett's reminiscences of life at the West of England College of Art have been invaluable. It was good to have Gordon Priest's reassurance that we had struck the right note in the chapter on the School of Architecture. I am grateful to Ann Fawcett and Roland Harmer for the piece about the Friends, a crucial body of supporters who have done much to further the interests of the RWA, while Michael Hitchings has provided information on the restoration work. Francis Greenacre has helped with information and suggestions, guided us around potential pitfalls and aptly selected for reproduction paintings by the Bristol School of Artists. I thank Clifton Arts Club for the reproduction of the painting by Beatrice Kerry; Andrew Wheeler kindly lent the photograph of an evening sculpture class in the 1930s. Copyright holders have been contacted where possible.

Thanks also to the staff at Queen's Road all of whom have been most helpful; initially the former Secretary, Rachel Fear for her enthusiasm for the project, and who put in hand the compilation of the statistical material which forms such a useful reference element; more latterly and especially Fiona Swadling who has been immensely helpful in locating information about past and present members, exhibitions and the documentation of the permanent collection; Di Franklin and Clare Wood for their much appreciated help; and finally, and emphatically not least, the President, Derek Balmer, for his encouragement and guidance throughout the book's preparation.

Publication has been a more than usually collaborative effort, and no-one has contributed more than our designer Stephen Morris, whose creative input has brought an elegance to the finished book.

I want to thank also John Hughes, for his continuing support and encouragement for the Redcliffe publishing programme and especially for his company's generous financial backing which has meant that this study of the Royal West of England Academy can be published at an accessible price.

John Sansom, September 2002.

President's Foreword

When I was appointed President-elect the first thing I did was to ask David Bethell to write a full and updated history of the Academy. We already had Donald Milner's praiseworthy 'Essay in Patronage' (published in 1985) but I envisaged a more expanded record with colour illustrations and an emphasis on where we stood after more than 150 years of survival. I use the word 'survival' advisedly because we are an institution that is all but here by default, and although being woefully under-funded have obstinately endured in spite of many setbacks and a singular lack of serious financial patronage.

As Dr Bethell began to delve into our archives, John Sansom of the Redcliffe Press approached us independently saying that he too was interested in producing a book about the Academy and so, fortuitously, a partnership developed that sees fulfilment in these pages.

Whilst it is understandable to take stock at a time when we are conscious of a new millennium and a mood for change is in the air, it is also appropriate that we move forward with confidence in our durability as we prepare with optimism for our future development.

The Appeal that we launched three years ago during the presidency of Peter Thursby has raised sufficient funds to enable us to restore and secure the fabric of the Academy for the generations to come. With this achieved, we can now attend to the exciting prospect of our recently formed partnership with the University of the West of England. Thus in years to come when further chapters are added to our unfolding story it will, one must hope, emerge that the foundations so carefully prepared have allowed those who follow us to build and move forward with confidence and success.

As each new generation runs with the baton and in turn passes it on, so we look back with gratitude to those whose hard work and dedication have allowed us to reach this point in our history, and to look forward to an even better future. This unique Academy,

owned and controlled by artists, has every reason to feel well satisfied with its past and present and every confidence in its prospects for the years ahead.

It has given me great pleasure to write these few words and may I, on behalf of our Past Presidents, Members and many Friends and supporters, thank our distinguished publisher and his splendid team of collaborators for producing such a valuable tribute to the Royal West of England Academy.

Derek Balmer PRWA, D Art (Hon) July 2002.

Beginnings

An alliance of a banker, a merchant and an ageing widow may seem an unlikely catalyst for the formation of a great art institution. But if three persons can be given the credit for founding the Royal West of England Academy they are indeed John Scandrett Harford, Philip William Skynner Miles and Mrs Ellen Sharples.

Harford, a partner in the local bank Miles, Harford, Battersby, Bayly and Miles of Corn Street in Bristol, and Miles, a partner in Miles & Co, merchants of Queen Square, were keen to found an art academy. Discussions with friends led to an inaugural meeting at the Bristol Literary and Philosophical Institution at the bottom of Park Street on December 21, 1844. That gathering of the Committee of the Bristol Academy for the Promotion of the Fine Arts, chaired by Harford, included both businessmen and artists.

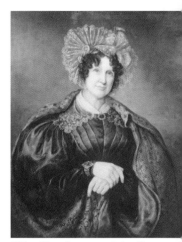

Ellen Sharples, portrait in oils by Rolinda Sharples, 1830. [RWA Permanent Coll]

Philip Miles seems to have been the moving force. The meeting heard of his discussions with Mrs Ellen Sharples of 3 St Vincent's Parade, Hotwells, who had offered to place the sum of £2,000 at the disposal of the Academy in return for interest payments of four per cent a year for the rest of her life. As she was then 75 and would die a little over four years later, this was, actuarially, a very generous offer. Significantly, it was accepted 'as an assurance of the continued existence of the Society as a means of raising an Art School'. The eleven gentlemen at this first meeting went home happy that they had completed a good evening's work. Not only had they been offered a substantial sum of 'pump priming' money, but they had negotiated the use of a room at the recently opened Victoria Rooms and one of the artists, William West, had reported that the Bristol Institution had offered space for an exhibition the following spring.

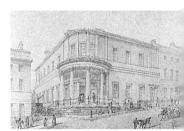

The Bristol Institution, Park Street, w/c by Alfred Montague, c. 1825.

The Academy was not established in an artistic void. Individual artists had long worked and exhibited in the city and an informal 'sketching club' had

A Sketching Party, E V Rippingille, pencil and pen & ink. [Bristol Museums & Art Gallery]

Portrait of Edward Bird RA, E V Rippingille, oil, 1817. [Bristol Museums & Art Gallery]

come into being in the early years of the century, with amateurs working alongside professional artists drawing from nature in the Avon Gorge and Leigh Woods and at Stapleton. Edward Bird RA, Francis Danby ARA and the influential amateurs, the Rev. John Eagles and George Cumberland, were closely involved. Local artists held their first exhibition as a group at the Literary and Philosophical Institution in the winter of 1824/25. By the following decade, the association briefly became more formal, and was known as the Bristol Society of Artists. Painters of the calibre of Samuel Jackson, William Müller, T L Rowbotham and William West were then working in the city. Bristol's artistic activity had been given a fillip in the 1820s when the retired businessman, George Weare Braikenridge, had embarked on his mission to record the topography of Bristol by commissioning watercolour drawings by such talented artists as Edward Cashin, George W Delamotte, Hugh O'Neill and James Johnson, as well as Jackson and Rowbotham. It is their work which forms the bulk of the priceless Braikenridge Collection now housed in Bristol

Museums & Art Gallery. All the while, Ellen Sharples' daughter, Rolinda, who would die in 1838 aged only 44, was also busy in Bristol, painting portraits and the animated scenes of Bristol life on which her reputation stands today.

As well as William West, four other members of the Academy's founding committee – Charles Branwhite, Henry Hewitt, Edmund Gustavus Müller (younger brother of the better-known William Müller) and Joseph Walter, the noted marine artist – were local artists. Practising artists were, however, in a minority on the committee from the very beginning, and it was the representatives of Bristol's educated middle-class elite who would direct the fortunes of the embryonic academy.

In some respects, this was a colourful period in Bristol's history. Late on the evening of December 11, 1844, only ten days before that inaugural meeting, Isambard Kingdom Brunel's revolutionary steamship the *ss Great Britain* had at last squeezed through the lock at Cumberland Basin and escaped down the Avon Gorge and into the Bristol Channel. She had been launched eighteen months earlier to great local excitement but had then been trapped in the Floating Harbour – a gigantic beached whale that very nearly turned into a white elephant. Two years earlier still, the celebrated engineer had opened the GWR rail link with London, but these historic landmarks were deceptive. Bristol was lagging behind its northern counterparts, and its heyday as 'second city' to

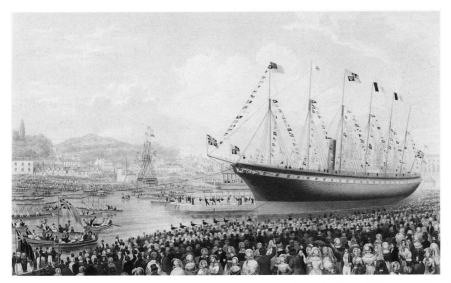

Launch of ss *Great Britain 19 July 1843*, Joseph Walter, lithograph. [Bristol Museums & Art Gallery]

London would eventually fade into folk memory. A new generation had grown up since the days when young scientists and poets were setting the pace: Humphry Davy experimenting with laughing gas in Dowry Square while the Romantic entourage around Samuel Taylor Coleridge and William Wordsworth, along with Bristol's very own Robert Southey, was transforming English poetry.

Bristol in the 1840s had a very sizeable population of around 150,000, based on present-

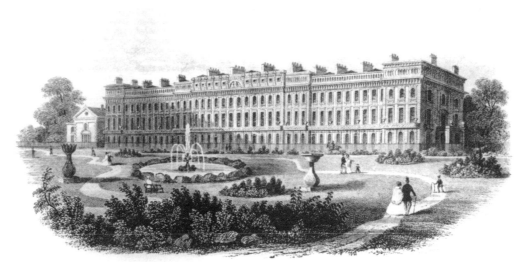

Victoria Square, Clifton: local residents were potential subscribers to the new art academy.

day boundaries, but it had lost ground to Birmingham and Manchester, while the population of Liverpool, Bristol's great maritime rival, was growing even more rapidly and would exceed 375,000 by mid-century. Historians disagree about the extent of Bristol's relative decline, but some commentators have seen the extraordinary delay in completing Brunel's Clifton suspension bridge – it was not finished until 1864, twenty-eight years after the foundation stone was laid – as symptomatic of Bristol's mid-century malaise. In 1851, Brunel himself would write: 'the whole must be closed as I am sick of it.' It is impossible to believe that the city fathers of Liverpool or Manchester, whose industries were expanding so much faster than Bristol's, would have countenanced such delay.

It was a city of immense contrasts. The speculative housing boom of the late eighteenth

century had been at the well-to-do end of the market. Merchants lived in gracious squares around the city centre, or in fine detached houses, and the crescents and terraces of Clifton housed the genteel middle-classes and their servants. But many more Bristolians were living in dire conditions in the central areas.

The contrast was highlighted in the accounts of visitors. In 1830, William Cobbett on his rural rides through the West Country was impressed. 'I shall never see another place to interest me, and so pleasing to me, as Bristol and its environs.'

Mid-nineteenth-century Bristol.

He found it a good and solid and wealthy city, with a people of plain and good manners. It was a 'great commercial city in the midst of cornfields, meadows and woods, and the ships coming into the centre of it, miles from anything like sea.' It was that picturesque, but increasingly hazardous, approach to the ancient port which was at the root of Bristol's commercial malaise and which saw more and more maritime trade gravitating to Liverpool.

In 1852, the popular novelist, Mary Russell Mitford, would echo Cobbett's sentiments.

'From Bath we proceed ... of Bath, its buildings and scenery, I had heard much good; of Bristol, its dirt, dinginess and its ugliness. Shall I confess – dare I confess, that I was charmed with the old city? The tall, narrow picturesque dwellings with their quaint gables, the wooden houses of Wine Street ... the courts and lanes climbing like ladders up the steep aclivities; the hanging gardens ... the bustling quays, and crowded docks; the calm silent Dowry Parade, with its trees growing up between the pavement like the close of a cathedral.' She responded, as had those artists setting out on their sketching parties, to the glories of the Gorge: 'I know nothing in English landscape so lovely or so striking as that bit of the Avon beyond the Hot Wells, especially when the tide is in, the ferry boat crossing, and some fine American ship steaming up the

river.' She was writing of the view, give or take a few hundred yards, which Ellen Sharples had enjoyed from her St Vincent's Parade drawing room.

But Parliamentary inspectors, looking closer, highlighted the seamy side of life. In the centre of the city, old houses – timber-framed and many-storeyed – might provide picturesque subjects for the new breed of Victorian photographers, but they were a serious threat to the overcrowded families living there. The Commission of 1845 reported: 'Bristol, with its climate known to be mild and salubrious, enjoys the unenviable celebrity of being the third most unhealthy town in England'.

Despite its relative decline, Bristol was still far and away the largest city in the west and the region's main centre for manufacture and distribution. Many fine commercial and institutional buildings were to be built in nineteenth-century Bristol, although few were to be on the scale of those of Liverpool or Manchester. The Bristol Academy of Fine Art would be one of the jewels in Bristol's crown. And yet it is difficult to avoid the impression that the climate for promoting new cultural initiatives was far from ideal in early-Victorian Bristol.

Part genteel elegance, part raucous industry: that was the Bristol in which the founders of the Bristol Academy sought to encourage the arts. The city, it must be said, had something of a reputation for putting commerce before culture. One eighteenth-century visitor commented that '[Bristol] people give themselves up to trade so entirely that nothing of the politeness and gaiety of Bath is to be seen here; all are in a hurry, running up and down with cloudy looks and busy faces', while the frustrated boy-poet, Thomas Chatterton had left Bristol in 1770 to seek artistic fame in London with the stinging verse

> Farewell Bristolia's dingy pile of brick
> Lovers of Mammon, worshippers of trick!
> … Farewell, ye guzzling aldermanic fools,
> By Nature fitted for Corruption's tools!

The Academy's first President, John Scandrett Harford, was the eldest son of the Harford who had commissioned William Paty to build Blaise Castle House in the last decade of the eighteenth century. He was Oxford-educated and widely travelled. He played the part expected of someone of his family's standing, sitting as a magistrate and

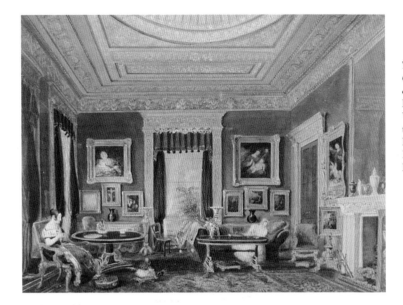

The drawing room, Leigh Court, T L Rowbotham, w/c, c.1840. The home of PWS Miles before his move to King's Weston House. Old Masters, then attributed to Guido Reni, Michelangelo, Murillo and Raphael are depicted. [Bristol Museums & Art Gallery]

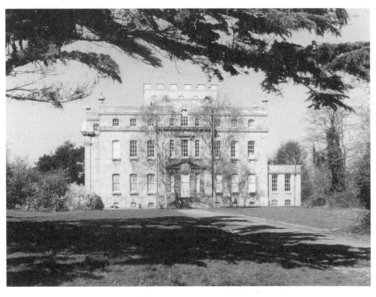

King's Weston House, home of Philip Miles, the Academy's first vice-president.

serving as a Deputy-Lieutenant for Gloucestershire and High Sheriff for Cardiganshire in 1829. He was elected by the voters of Cardigan to represent them as their Member of Parliament in 1841. A man of taste, who had visited Italy to research a life of Michelangelo, and of moral conviction, he was a model of Victorian paternalism, ideally suited to the uplifting role many saw the Bristol Academy playing in the cultural life of the city.

Philip Miles, who sat alongside Harford as the first vice-president and was destined to

become president, shared his friend's background and ideals. He was then living in a fine neo-classical mansion, Leigh Court, but was soon to move across the river to a still grander pile, King's Weston House, which had been designed by the eminent architect Sir John Vanbrugh in 1710. Miles, whose father was reputed to be Bristol's first millionaire, served the city as Conservative MP over of period of more than thirty years. While an MP, he also kept a house at 44 Belgrave Square in London.

Portrait of William West,
drawing by NC Branwhite.

Portrait of Samuel Jackson,
British School, c.1820-24.
[Both illustrations: Bristol
Museums & Art Gallery]

The other non-artist committee members, who were to assume the role of trustees, were from the business and professional middle-class community and must have shared the lofty ideals of Harford and Miles. For their part, the artists who joined the Park Street meeting had more prosaic aims; their motivation, naturally, was to encourage the sale of work by local painters and sculptors. They were listened to in committee, but the businessmen took the decisions.

In his 'Essay in Patronage' Donald Milner, president from 1974-79, likened the clear social distinction that would have existed in 1844 between a patron or arts society member and the professional artist member to that between cricket's 'Gentlemen and Players'. Control of the Academy would remain firmly in the hands of the 'lay' members for more than a hundred years.

The traditional patronage of the aristocracy was giving way to industrial and business patronage and a consumer market for works of art eagerly taken up by self-made connoisseurs. Most famously, Henry Tate amassed a fortune from sugar refining and built a suitably saccharine collection of paintings to go with it. A Leeds merchant, John Sheepshanks, was to leave his collection to the Victoria and Albert Museum, while Robert Vernon, who had made a fortune horse-trading during the Napoleonic wars, left his to the National Gallery. The great collection in Liverpool's Walker Gallery is a direct result of the port's flourishing shipping trade (developed, ironically, largely at Bristol's expense) and the enlightened patronage of men like the shipping magnate, Frederick Leyland. There is scarcely a northern city or town of any size which doesn't owe part of its municipal collection to a local industrialist

anxious to be immortalised by an ostentatious display of purchased art. In Bristol, which would not have a publicly owned art gallery until 1905, the natural focus for any munificence that might be going in the nineteenth century was the Fine Art Academy.

The proposed Code of Rules for the new academy in Bristol was accepted by the artists and formalised at a meeting held on Boxing Day, 1844. Among the aims of the fledgling academy were 'the advancement of the art of Painting in oil, Fresco, and Water colours, of drawing in chalk, of the study of Sculpture and Architecture and also of any other branches of the Fine Arts which the Committee may from time to time authorise'. For these purposes, five artists were to be included in the 13-strong Committee of Management, the others being the President, Vice-President and the six lay members who would be trustees. The artists invited by the trustees to serve on those early committees were Charles Branwhite, Samuel Jackson, Robert Tucker, Joseph Walter and William West.

The rules detailed the criteria for electing artist members, who could be either male or female. Artists who wished to become members but were deemed not sufficiently advanced in his or her particular branch of art were offered the privilege of studying at the Academy free of charge as students. Artist members would be required, on ceasing to be a member, 'to present a picture or other work of art of his own composition to the Academy'. There would be an annual exhibition of member artists' works with others invited to exhibit at the discretion of the Hanging Committee. The Bristol Art Union (a lottery in which winners took their prizes in pictures and which survived until 1939) was to be taken over by the Academy and prizes would be given, Academy funds permitting. The first prize would be called 'The Sharples Prize'.

Artist members were required to live and practise as a painter, sculptor or architect within ten miles of Bristol. Amateurs living similarly within ten miles of Bristol for the previous twelve months were to be allowed to study at the Academy for a fee of five shillings a month.

Things were moving quickly and in the following month, January 1845, the President addressed a letter to the citizens of Bristol:

Sir, We beg to inform you that the munificence of a Bristol lady has

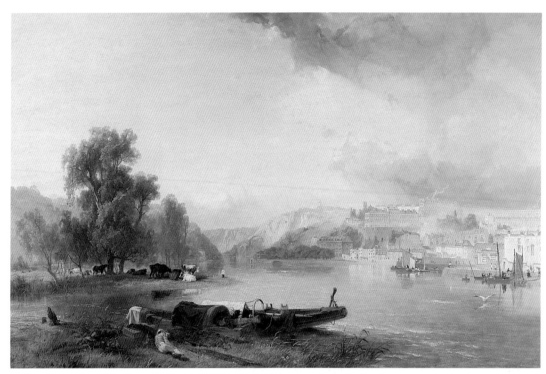

Clifton from Ashton Meadows, J B Pyne, oil 1836. [Bristol Museums & Art Gallery]

prepared the way for the formation of an Academy of Painting, which it is hoped will not only foster and call forth native genius in the City and Neighbourhood, but also tend to promote just principles of taste, and to minister in various ways to the public gratification and instruction. This is an object in which every Citizen of Bristol ought to take a lively interest. Liverpool, Manchester and Birmingham have already founded similar institutions. We must not be left behind in the career of intellectual improvement. The completeness of the projected Institution must depend upon the prompt response of the Bristol Public to the appeal which is now made to them for necessary contributions in aid of a fund for the erection of a suitable building. Subject to the Rules of the Academy and a list of Subscribers, your support is earnestly requested.

I have the honour to subscribe myself on behalf of the Management Committee.

Sir, Your obedient servant, John Harford, President

Liverpool's Academy had been formed in 1810, with the primary aim of teaching and its

exhibitions were held as a means of publicizing, and in part financing, this objective. Its counterpart in the rival Lancashire city, Manchester Academy of Fine Arts was founded in the late 1820s as the Royal Manchester Institution. Peter Davies, writing in *A Northern School*, saw the establishment of the original Institution as meeting a pressing need for the thriving and growing business centre of Manchester to nurture a full artistic identity. Without the benefit of Bristol Academy's egalitarianism (which no doubt reflected the fact that its great benefactor was Ellen Sharples), Manchester women were not admitted as members of their Academy for another fifty years. Amateurs were excluded until after the First World War.

Sunset: Snuff Mills, Stapleton, Henry Hewitt, oil. Hewitt was a founder member of the Academy. [Private collection]

In time-honoured fashion, the 'great and the good' were invited to become patrons or 'associates' of the Bristol Academy. Among those who responded were Prince Albert, who sent a cheque for £25, the Bishop of Bristol and Gloucester, the Duke of Beaufort and Earl Fitzharding. Isambard Kingdom Brunel accepted the Management Committee's invitation to become an associate member.

The Academy's minute books from that time reveals a sense of urgency, reflecting the aspirations of both the Trustees and the Body of Artists, as they were lumpishly designated, to hold exhibitions and to find a site for a building in which a School of Art could play an essential role.

Dear Mr M

That you are so greatly interested in the Academy for the promotion of the Fine Arts is particularly pleasing to me, I hope & believe it will be productive of all those advantages which I anticipate & which you so eloquently express. If the Bristolians are only now liberal all preceding neglect of Art will be forgotten: an elegant edifice will arise an ornament & honour to the city which within its walls will contain a succession of the various beauties of Art, as the Institution in Park street now contains the various beauties of Nature. To artists & amatures it will be an especial advantage inducing steady application and arduous exertion so essential to the productions of genius and to all lovers of taste it will afford an elegant ever varied & delightful source of amusement.

Ellen Sharples' copy of a letter to Philip Miles c.1844/45.

The Sharples Family

Mrs Ellen Sharples, without whose generosity the Academy might well have foundered in its early years, was one of a remarkable family with strong associations not only with Bristol but also the United States of America in its formative years. The Sharples family of artists flourished as a family practice of portrait artists at the end of the eighteenth and beginning of the nineteenth centuries. Their nucleus was James Sharples senior (c.1751-1811), best-known for his portraits drawn in pastel although he also painted in oil. He was a talented but not exceptional artist who also delighted in inventions, which diverted him from his drawing, and who had the perspicacity to spend two periods of his career in the newly independent United States of America. There he made a lucrative living from drawing the statesmen and other prominent figures of that thriving new nation. His third wife, Ellen (née Wallace, 1769-1849), whom he married in about 1787, copied his pastel portraits to meet the demand and their work can be difficult, if not impossible, to distinguish. None of them is signed although there may be contemporary inscriptions on the backs of the frames. In later years they were joined in the business by their son, James junior (c.1788-1839) and James Sharples' son by his second wife, Felix Thomas Sharples (1786-early 1830s). Felix was an infant when his father married Ellen and was raised by her. He was to spend his adult life in America, largely in Virginia, where he continued the family's tradition of drawing pastel portraits. James and Ellen's daughter Rolinda (1793-1838) also made portraits throughout her life but preferred to work in oil.

Today, after the attentions of feminist art historians, Rolinda Sharples is the most prominent artist of the family. From 1812 until her untimely death, she lived in Bristol and although she continued to paint individual portraits throughout her career her achievement was in multi-figure genre pictures of everyday life often set in a local context. As a woman, she did not socialise with the other Bristol School artists, but she was familiar with their work and her style is part of the tradition of local genre painting

exemplified by Edward Bird (1772-1819) and Edward Villiers Rippingille (1798-1859). It was unusual at that time for a woman artist to specialise in genre scenes and she enjoyed modest critical and popular success when her work was exhibited in London and provincial cities such as Liverpool and Carlisle.

The details of the lives of the Sharples family are well known because Ellen Sharples, a pragmatic, philosophical and resourceful woman, kept a diary from 1803. She also compiled one retrospectively, from various notebooks, for her talented daughter who was too busy to keep her own. There are also letters, written in the final decade of Ellen's life, when she was trying to come to terms with her grief and loneliness after outliving her husband, two children and stepson.

James Sharples senior was born in England about 1751 and was sent as a youth to France to train for the Church. On his return he abandoned those studies in favour of becoming an artist and exhibited at the Royal Academy from 1779 to 1785. In common with many eighteenth-century artists he was itinerant and lived in several cities in the pursuit of work. In 1781 he was living in Bath but also working in Bristol and was described as a 'Portrait Painter in Oil and Crayons'. He may have been following the visitors who took the waters at Bath in the winter and at Bristol in summer, for in July that year he was at the Hot Well. He then exhibited over 100 portraits in central Bristol, at a milliner's in Clare Street, and advertised for custom from 'the nobility and gentry of Bristol'. By 1783 he was in London. Nothing is known of his first two wives or whether the son by his first, George, was the G Sharples who was to exhibit portraits at the Royal Academy from 1815 to 1823. In about 1786 James was widowed for the second time, probably soon after the birth of Felix, and went to live in Liverpool where his only brother lived. Within a year or so he had married the much younger Ellen Wallace. She was from a Quaker family and they had first met at Bath, where she had been a pupil at one of his drawing classes when barely in her teens. Their first child, James junior, was probably born in Liverpool in 1788 and was brought up with his stepbrother, Felix. After a few years the family returned to Bath and first lived on the outskirts before buying a house in fashionable Lansdown Crescent.

Rolinda was born on September 3, 1793, probably in Bath. Her parents then made the bold decision to go to America to further James's career and rented out their Bath

house. Disaster struck soon after embarkation for their ship was seized by a French privateer and the passengers were imprisoned at Brest for seven months. It says much for their determination that, after a miserable imprisonment with three young children, they then resumed their long voyage. The date of their arrival in the United States of America was probably during 1794. The Declaration of Independence had been made in 1776, although Great Britain had not acknowledged it until after her defeat in war in 1783, and this new nation of America ran from Maine to Georgia on the eastern seaboard and extended to the Mississippi in the west and the Great Lakes to the north.

Although Ellen never recorded the precise reason for their first visit to America it was presumably so her husband could form a collection of portraits of eminent Americans and bring them back to a curious audience at home as well as making a living while he was there. Later she mentioned the 'professional success that America certainly possessed' (*Diaries of Ellen and Rolinda Sharples*, March 25, 1811). Pastel was an eminently practical medium for a skilful itinerant artist as small likenesses could be produced quickly and cheaply. James was armed with letters of introduction to distinguished figures with a request to draw their portraits for his own collection. This was said to take only a couple of hours and was either a profile or three-quarter face. The artist then retained the original portrait, but in the days before photography the sight of it usually resulted in an order for a copy from the sitter and other commissions from family and friends. The price for a profile portrait was usually $15 and $20 for a three-quarter face. He worked on a blue/grey paper which had had any irregularities smoothed down. It usually measured slightly over 9" x 7" (228mm x 178mm) but was occasionally oval, and he applied the finely powdered pastel pigment with a brush as well as using it in crayon form. As was usual at the time, the pastels were blended together with a finger or a tool called a stump. James's work followed a distinctive format and it was said that he used mechanical drawing aids. Itinerant portraitists of the time typically used a physiognotrace (utilising light to cast a life-size shadow of the sitter's profile) and a pantograph (a jointed copying frame) to make a scaled reduction of the tracing of the profile. Given James Sharples' love of inventions it is quite probable that he used these aids, or perhaps one of his own devising, for his profile portraits.

All of his drawing materials, Ellen and the children, travelled around the States in a one-

horse travelling coach which James the inventor had designed himself. His business venture in America was a great success and he was highly prolific, earning the respect of his customers for his skill, his industry and his courteous manners. 'There certainly is no country where talents and useful accomplishments are more appreciated nor none where greater hospitality or kindness can be shown to strangers, who by letters of introduction are known to have been respected in the land from whence they came' (*Mrs Sharples Letters*, to Miss Pigott, April 10, 1843). There are many Sharples family pastel portraits in public and private collections in the USA today including a large collection at the Independence National Historical Park in Philadelphia.

The family also seem to have lived in New York and then settled for a while, in 1797 or earlier, in Philadelphia. Philadelphia was the seat of government and the most important city in America at that time so there were plenty of potential customers. It was at this point that Ellen decided to use her amateur skills in drawing for the financial gain of the family. She was convinced that educated women should have a skill which would enable them to earn a living if hard times should reduce their income. Years later she recalled this moment in her diary: 'The continual fluctuation of the funds, and other property in which our money had been invested, the uncertainty in mechanical pursuits, in which Mr. S. delighted: all had an influence in deciding me, soon after our arrival in Philadelphia, where congress then assembled, to make my drawing, which had been learnt and practised as an ornamental art for amusement, available to a useful purpose. Mr. S. was generally engaged drawing in crayons the portraits of the most distinguished Americans, foreign ministers, and other distinguished visitants from Europe. Copies were frequently required; these I undertook, and was so far successful, as to have as many commissions as I could execute; they were thought equal to the originals, price the same: we lived in good style associating in the first society' (*Diaries of Ellen and Rolinda Sharples*, synopsis 1806-8). Ellen was essentially a copyist, and remained so, admitting that she was extremely nervous when she drew from the life. However, it is so difficult to differentiate her copies from her husband's original drawings that many public collections simply catalogue the portraits as 'Sharples Family'.

The politicians James drew, almost certainly during his time in Philadelphia, included John Adams (the second President of the USA 1797-1801), Thomas Jefferson (Vice-

President and later the third President 1801-9) and the dashing Albert Gallatin (a Swiss who had emigrated to America and became Secretary of the Treasury 1801-13). Most importantly, from the financial point of view, James had obtained sittings with George Washington and his wife Martha. He drew profiles of them both and also a three-quarter face of the 'Chief', as he was known. This seems to have been in 1796/7 after Washington had retired from office. The profile was the one which was most copied by the Sharples family and Katherine McCook Knox identified about thirty versions in her book on the Sharples; there were doubtless more. Bristol Museums & Art Gallery have a profile and a three-quarter face. Although both are catalogued as being original drawings by James there is always an element of doubt, although the three-quarter face is particularly lively and may indicate that it was the version taken from life. Later in

Albert Gallatin, James Sharples senior, pastel c.1797. [all illustrations in this chapter, Bristol Museums & Art Gallery]

1797 the Sharples were again living in New York and seem to have stayed for a couple of years. Then in 1801 they received news of a problem concerning the leasing of their Bath house and, as they were also worried about a possible American war with France, they returned home. They had spent seven or eight years away and it had been both a financial success and socially enjoyable. It has also recently been acknowledged that their work 'made a major contribution to the growing Federal portrait industry' (Kathryn Metz, 1995).

When they returned to Bath they lived in Lansdown Crescent again for a while before selling it and buying 2 Grosvenor Place, a Georgian terrace on the edge of the city. This was on Ellen's instigation, as she wished to remain in Bath. James exhibited his portraits of Americans there in 1802 and although a catalogue was published an original copy of it has not yet been located. It seems to have listed 229 portraits, and included a few English sitters. The two boys were soon old enough to draw pastel portraits professionally, which they did when Felix was seventeen and James junior fifteen. Felix was of a restless disposition and at that time, 1803, was living in lodgings in Bristol. It was also the year that Ellen started her diary. It is a fascinating document and full of her delight in the home education of her eager and intelligent daughter, Rolinda. Ellen

recorded a formidable list of the classical and contemporary authors they both read, described rambles in the countryside, dreaded the war with Napoleonic France, listed the copies of portraits drawn and made her first attempts at miniature painting on ivory. These were again copies of portraits and she was pleased with the results: 'Should I excel in this style of drawing it will be a great satisfaction to me. I shall then consider myself independent of the smiles or frowns of fortune, so far as the fluctuating and precarious nature of property is concerned' (*Diaries of Ellen and Rolinda Sharples*, June 1803).

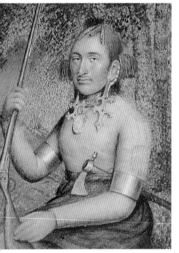

North American Indian, Ellen Sharples, w/c on ivory 1808.

She was again making sure she could survive on her own, probably mindful that her husband was some eighteen years her senior. One of her miniatures on ivory, *North American Indian,* is unusual as it does not appear to have been based on one of her husband's originals. An ethnographer has identified the sitter's costume as approximating to the style of an Irquoian or Algonquian ally of the British in the eastern Great Lakes region and Ellen recorded making this copy in her diary in 1808.

James senior was engaged in his inventions rather than portrait drawing and in 1802 he had registered designs for improving steam engines: 'The mechanical pursuits in which Mr. S. is always greatly interested frequently occasion his visits to London, where he finds more skillful workmen to employ in his experiments, making of models etc. and he sometimes exercises his profession' (*Diaries of Ellen and Rolinda Sharples*, April 1804).

Unfortunately, his talents were focused on the process of invention and not on bringing them into use for he moved on too quickly to the next idea. In April 1804 James wrote to Ellen from London, asking her to visit him and bring the ten-year-old Rolinda with her. Of the many sights she saw, the young girl was much impressed with the British Museum and the Royal Academy exhibition. James had taken some time off from inventing to draw some pastel portraits and Ellen was gainfully employed each morning with making miniature and pastel copies as well as some original portraits.

The pitfalls of attribution of portraits to individual members of the family and the identification of the original version are demonstrated by Ellen's note that she made these copies 'for our collection'. In America, it seems to have been the original which was retained. Perhaps in the case of famous sitters, where many copies were needed for sale,

the original was kept by the Sharples while with other commissions the original went to the client and a file copy was kept as a record. However, there can be no hard and fast rule. James senior and junior, Ellen and Felix all made copies as the business demanded. Ellen was primarily a copyist and the original work of hers which is known is stiffer and more hesitant than her husband's. Her copies of his work, however, are indistinguishable. Felix and James junior were also so competent by 1805 that they were nearly independent of their parents. They both worked away from their parents' home and Felix was in London in 1805. No pastels are known to be by Felix until later, when he was working in the southern states of the USA, and it is possible that his English work is attributed to his parents and stepbrother or is simply anonymous. The portrait of his father attributed to James junior is in the family style and was probably made about 1805. There are only a few documented portraits by James junior; at his best he is as good as his father, but his style can be tighter and smoother. The backgrounds also lack the broad strokes of pastel typical of James senior. The problems of attribution to the Sharples family have been compounded by the many portraits by unknown artists which have been attributed to them without documentation or even stylistic resemblance.

Among the eminent people James senior drew in England were Sir Joseph Banks (the botanist who had accompanied Captain Cook on his first expedition, later President of the Royal Society), Humphry Davy (chemist, inventor of the safety lamp), Sir William Herschel (astronomer), Dr Erasmus Darwin (naturalist and poet, grandfather of Charles Darwin), William Strutt (inventor, especially of improvements in stoves and the spinning-mule), and Robert

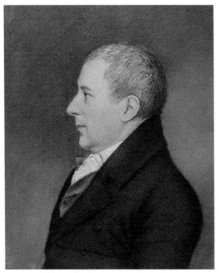

James Sharples senior,
James Sharples junior, pastel c.1805.

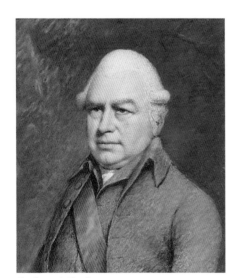

Sir Joseph Banks,
James Sharples senior, pastel c.1802.

29

Southey (Bristol-born Poet Laureate). As with all of the Sharples' work, it is difficult to know when the pastel portraits were made or whether the versions now in the city's collection are the originals by James senior or copies by Ellen or their children. One portrait which Ellen certainly drew herself from life is Arthur M Browne (a lawyer who was Prime Serjeant of Ireland). James junior was intended to make the portrait but he was away from Bath at the time. Ellen related in her diary in October 1803 that she was prevailed upon to do the work, although very nervous of her abilities. The portrait is a little stiff and hesitant but both client and artist were pleased with the result and Ellen made a copy for the collection; this is the version illustrated here.

Arthur M Browne,
Ellen Sharples, pastel 1803.

The family had been considering returning to America for some time, as they still had property there, and in 1806 began to make the arrangements. The Bath house was sold, belongings packed and everything sent to Bristol where they lodged for a while. They then booked on the New York packet and embarked on a summer's day. Before they reached the mouth of the Avon the packet went too close to the shore and struck a rock, necessitating a month in dock for repairs. During that time James and Ellen decided not to proceed with their journey for financial reasons. They had chosen a time to travel when their investments would be likely to increase but hostilities with France meant that they were falling instead. Their sons, however, begged for permission to go to America on their own and embarked in high spirits. Once there they went their separate ways; James junior staying in New York and Felix going to Philadelphia. James senior, Ellen and Rolinda remained in Bristol where the girl 'drew the portrait of a young lady of her acquaintance in crayons, which was greatly admired, for the correctness of the likeness, and which decided her becoming a professional artist just as she attained her 13th year' (*Diaries of Ellen and Rolinda Sharples*, synopsis 1806-8). In the spring of the following year they visited London and stayed for over a year. The purpose was to broaden Rolinda's education while she also worked at her portraiture. Ellen exhibited portraits at the Royal Academy for the only time in 1807 and was described then as a miniature painter.

They left London in July 1808 and rented apartments in Park Street, Bristol, awaiting an opportune moment to sail for America. They had to wait nearly a year, during which

Ellen painted a few miniatures, James drew pastel portraits and some landscapes (none of which are known today) and Rolinda played her new pianoforte. She did not draw professionally during this year. At the end of May 1809 they embarked on the brig *Nancy* for New York with Mary, their servant. Ellen described the gruelling voyage in her diary in vivid detail. Their bottled gooseberries went mouldy and spoilt. There was a terrible gale and one of the pigs on board died as well as some of the ducks and chickens. They were becalmed, and everybody became bored and irritable. They watched whales, sharks, porpoises and Portuguese men-of-war. Sometimes they could sit on deck in the moonlight, sometimes Ellen could sew. It took over seven weeks, but eventually they reached America.

It had been nearly three years since James and Ellen had last seen their sons, but James junior was not in New York when they arrived as he was working in Albany, some 150 miles up the Hudson river. Felix was presumably in the south. They stayed in New York for a couple of weeks, went house-hunting, and then caught a steam boat to Albany where James was on the quay to greet them. On their return to New York they found a suitable house to rent and Ellen furnished it with enthusiasm. James senior started work, and by December Ellen was making copies of his portraits again.

The following year, 1810, was based in New York, with James senior making an excursion to the Niagara Falls. Ominously, Ellen mentioned he was troubled with pains in his side. The autumn saw a pleasant interlude to visit old friends near Philadelphia but James senior's health continued to decline. In November he was diagnosed with angina pectoris and at the end of January he made his will. It was a particularly severe winter in New York and the extreme cold added to the family's misery. James died on February 26, 1811. During his final illness he had stressed that it was his wish that Ellen should return to England with James junior and Rolinda. He was worried about war between Britain and America (which the latter declared in 1812) and had transferred the considerable sum of £5,000 to London in anticipation of their return. Felix, barely mentioned by Ellen since their arrival in America, arrived just too late from Virginia. As he wished to stay in America he received his father's lands in Pennsylvania and Ellen gave him many of their portraits of distinguished Americans, books and drawing materials. An auction disposed of their household furniture and more portraits. On May

29, Felix accompanied them on board their ship to Liverpool to say goodbye – they would never meet again. As Ellen realised, he was a rover, and he returned to the southern states. He made pastel portraits there in a different style from his father and seems to have died in the early 1830s.

After the voyage Ellen and her children stayed in Liverpool for a few weeks, visiting relations of her late husband. George (James's son by his first wife) is mentioned as a daily visitor. Ellen and Rolinda then went to London to prove the will: 'Going to the bank, and the Attorneys, caused me a great deal of agitation, and when I had my name to write, my hand shook so that it was with difficulty I could do it. Girls as well as boys, should be accustomed to transact business of various kinds and to enter publick banks, and offices, which would prevent the distressing sensations which women experience when obliged to do it late in life' (*Diaries of Ellen and Rolinda Sharples*, November 1811). She was in her early forties and was in fact a most organised and capable woman. Back in central Bristol they rented apartments in Orchard Street and later moved to Clifton. In the summer of 1812, when she was nearly nineteen, Rolinda began to paint in oils. She painted her first portrait at the beginning of the following year which, ambitiously, was of her mother 'as large as life'. She was also still making portraits from life in pastel although worked increasingly in oil. James junior spent most mornings drawing small pastel portraits, and both of them received many commissions.

At the end of March 1813 they moved to apartments in Sion Spring House, Clifton, with magnificent views across the gorge to Leigh Woods. Rolinda's skills in oil improved quickly that year and she started another portrait of her mother as she was dissatisfied with the one made earlier. It should be noted that neither of these is the *Portrait of Ellen Sharples*, as has been published in error many times, which now hangs at the Royal West of England Academy. That portrait shows a deceptively youthful Ellen, although aged about sixty, dressed in a highly fashionable dress of circa 1830. In 1814 Rolinda painted her first miniature on ivory, which was a copy. She also painted a self-portrait in oil and drew from plaster casts and an anatomical book to improve her figure drawing. Her training as an artist so far had been what she had learnt in the family firm and her knowledge of other artists' work. In Bristol they went to see Edward Bird's historical painting *The Surrender of Calais* (presented to Princess Charlotte to mark his

appointment as Historical Painter to her, present whereabouts unknown) and found it very beautiful. It is probable that they also visited the 1820 posthumous exhibition of Bird's work in Bristol, organised by his friends for the benefit of his family, as their prime interest was in portrait, genre and historical painting.

In May 1814 the three of them went to London for a few weeks to look at paintings, go shopping, including for artists' materials and plaster casts, and visit the theatre. They spent six hours at the Royal Academy, visited Henry Bone to see his miniature portraits on enamel, went to J M W Turner's gallery where they admired the sea pieces but not the rest of his work (his technique was too bold), the British Institution's historical exhibition to see Hogarth, Gainsborough, Wilson, Mengs and Zoffany, and Richard Westall's exhibition where they found some of the paintings gaudy and unnatural. George Cumberland in Bristol had given them a letter of introduction to Thomas Stothard (a book illustrator as well as painter of poetic subjects in oil) and he showed Rolinda how to make up her palette and discussed new mediums for oil painting with her. They purchased plaster casts to send to Clifton, saw the Elgin Marbles at Burlington House and went to the British Museum. They visited private collections to view Old Masters, the studios of fashionable portrait painters including Sir Thomas Lawrence, Sir William Beechey and James Northcote, and salerooms and dealers' shops. At John Singleton Copley's, the elderly American artist conversed with them at length and they had the highest praise for the finish of his historical subjects. Rolinda also had her first documented tuition: a morning's formal lesson from Philip Reinagle (1749-1833) for two guineas where Ellen was gainfully employed in writing down his instructions. Reinagle was a portrait, animal, sporting and landscape painter.

Ellen's writing in her diary up to this point is entertaining and informative but from 1816 to 1836 the character of the narrative changes. She now lived through her daughter's achievements and compiled a diary for her retrospectively, using various notebooks where Rolinda had jotted down details of her busy life. Sections which summarise gaps in the diary are written in Ellen's familiar flowing style. The main interest of Rolinda's diary is the account it provides of her work, enabling many paintings to be identified and dated accurately, and it also gives a few clues to her personality. She was diligent, hard-working and evidently charming company but there

The Artist and her Mother, Rolinda Sharples, oil on panel 1816.

are also glimpses of an ironic wit. In March 1816 she began the self-portrait with her mother and their close relationship, and Ellen's nurturing of the talents of the daughter she had so carefully educated, is evident. They continued thus, with Rolinda dedicated to her painting and her music, for two decades. James junior continued to make portraits and also drew still-lifes in pastel, few of which are signed or dated. They are rather plodding works and were perhaps made when his health began to decline and he was less able to practise his profession of portrait drawing.

The evidence of the diary shows that it was quite respectable for a woman to support herself as an artist. Ellen had supplemented the family's investment income as a copyist of her husband's work and was delighted when her daughter chose to be an artist and began to be paid for her portraits. Rolinda made portraits throughout her life, although few are known today outside the Bristol Museums & Art Gallery collection, and incorporated those of friends and acquaintances into the lively scenes of Bristol life for which she is remembered. There were evidently no social barriers and no prejudice against a professional woman artist who was able to sell and exhibit her work throughout the country. Rolinda's only British precursor seems to have been Maria Spilsbury (1777-c.1823, later Mrs John Taylor) who was a prolific artist exhibiting at the Royal Academy, British Institution and later in Dublin. Spilsbury painted portraits, genre scenes which were often of children and subjects from the scriptures.

Still Life with Oysters, Fish and Sea Shells, James Sharples junior, pastel c.1830.

In 1817 Rolinda began her first multi-figure piece, *The Cloak-Room, Clifton Assembly Rooms* (Bristol Museums & Art Gallery), which was finished the following year. Over thirty figures are arranged, frieze-like, at a social gathering which is today often used by publishers to embellish the covers of Jane Austen's novels. Although technically naïve, it has a charm and accuracy of observation which still makes it one of her most popular works. Rolinda then started and abandoned a painting of a concert in a Clifton drawing room and completed a market scene which in 1820 became her first exhibition success. Her genre works were usually based on Bristol scenes, but did not always refer to Bristol in their title or pretend to be a topographically correct view of the city. For *A*

Market (present whereabouts unknown) she made preparatory drawings of a local market and was often at her easel at 6am to work on the painting. It was sent to London and the family soon followed. Reinagle suggested some additional glazing and, with four smaller works, it was submitted to the Royal Academy. As today, many hundreds of paintings were rejected and it was a considerable achievement that all of Rolinda's works were both accepted and well hung. They were also well reviewed in periodicals, much to the delight of the Sharples. They visited the Royal Academy exhibition nearly every day and there was always a crowd around *A Market*, just like that around David Wilkie's and William Mulready's genre scenes. The vogue for genre or narrative works added to the problem of the crowded galleries at the Royal Academy and increased complaints that visitors couldn't see the paintings easily. Such scenes must be observed closely, the expressions of the figures have to be read and interpreted in order to deduce what exactly is happening in the painting and this takes the viewer longer than, for example, looking at a portrait or landscape. Although Rolinda's work was not of the calibre of Wilkie or Mulready, it still demanded close scrutiny.

During their London visit Rolinda had ten lessons from Reinagle, costing two guineas for two hours, copied an Old Master painting and practised glazing. These were the only formal lessons she had, otherwise she had learnt from the family practice and her own studies. They bought a small easel and that summer it went with them on an excursion to the River Wye, on the other side of the Severn. They stayed for about six weeks drawing at Chepstow Castle and Tintern Abbey. Rolinda also painted in oils out-of-doors. On their return to Clifton they moved to a newly built house at Lower Harley Place, on the edge of Clifton Down, where Rolinda had one room for painting and James had another for his portrait business. Rolinda began a painting of *Rownham Ferry* (Sotheby's, London, July 15, 1992, lot 85, present whereabouts unknown) which was exhibited at the Royal Academy in 1822. Although there are many more figures than *The Cloak-Room, Clifton Assembly Rooms* they are still arranged in a frieze-like manner. Next she began *A Mouse!* (present whereabouts unknown) which was a purely imaginary piece. A mouse had intruded into a parlour after dinner, the ladies took refuge on the sofa or fainted, a gallant hussar drew his sword and a small boy advanced for the kill. It was exhibited at the Royal Academy in 1824 and attracted much attention and a favourable press. Charles Westmacott's *Annual descriptive and critical Catalogue to*

the exhibition called it 'a very clever little gem, rich in humour and attractions'. The Carlisle Academy wrote requesting it and other examples of her work for their exhibition and she sent it along with *A Market*. *The Carlisle Patriot* was flattering in its review of both pictures and at the close of the exhibition, when a grand dinner was held, one of the toasts drunk was to Miss Sharples.

Rolinda often worked on several paintings at a time and was thorough in her preparation. For *St James's Fair*, another Bristol subject (now Biddick Hall, Co. Durham), she cut out figures in cork, had a model made of part of the fair and made a model paste-board caravan herself. A local carpenter made a lay-figure to her own design. It was a more complex composition than she had attempted to date and was packed with figures and incident. Comparable contemporary works by other Bristol School artists, with which she may well have been familiar, are EV Rippingille's *The Recruiting Party* of 1822 and Samuel Colman's (1780-1845) *St James's Fair* of 1824 (both of which are now in the city's collection). Rolinda's fair painting was exhibited in London in 1825 but not at the Royal Academy for she now showed her work at the newly established Society of British Artists exhibitions at Suffolk Street, off Pall Mall. The purpose-built gallery had opened the previous year and EV Rippingille and his brother Alex had both showed a genre painting at the first exhibition. The society was formed to extend the gallery space available in London for artists and the emphasis was on selling their work and displaying it in more congenial and less crowded galleries than the Royal Academy. The Sharples were gratified to see *St James's Fair* hung in a conspicuous place and it quickly sold to a Dr Mackey for 180 guineas. He immediately commissioned a companion painting for it. This was *The Stoppage of the Bank* (now Bristol Museums & Art Gallery) which Rolinda suggested as a subject suited to the depiction of a wide variety of expressions in the figures. Little is known about Dr Mackey whom they met only once. He said he had purchased, or intended to, a fine estate near Keswick and wished to form a gallery of British paintings where a series of Rolinda's paintings 'would become one of the attractions of the lakes' (*Diaries of Ellen and Rolinda Sharples*, synopsis 1825). He asked to see more and she sent *A Mouse!*, *A Market* and *Rownham Ferry*. He bought them all for a total of 250 guineas. *The Stoppage of the Bank* was completed in time for the 1827 Suffolk Street exhibition but Dr Mackey was not to be seen. There was a rumour that he had purchased property in the Isle of Wight but then

they heard he had lost his fortune speculating in Mexican Bonds. It was ironic that the large genre work Rolinda had just completed for him showed a family in a provincial street, loosely based on central Bristol, who had just lost all their money on the collapse of a bank. She had problems with the painting, which is awkward in its perspective and the relationship of the figures to the street architecture behind them, and retouched it during 1830-1.

In 1827 the Society of British Artists unanimously elected Rolinda an Honorary Member. She continued to exhibit with them and also at the Academies in Carlisle, Liverpool and Dublin. Other exhibitions were at Leeds, Southampton and Birmingham. Bristol, of course, had no Academy yet but Rolinda was able to exhibit locally on a few occasions. She exhibited at the Bristol Institution's exhibition of British artists in 1829 and with the Bristol Society of Artists at their first exhibition in 1832 and again in 1834. She also continued with portraiture, including at life-size, and seems to have been much in demand. *The Clifton Race-Course* is first mentioned in 1829 when she began to make preparatory sketches, although it was not completed until 1836. Annual horse races had been held on Durdham Down for much of the eighteenth century and until the late 1830s; the diary records that the family enjoyed going to them. It was an ambitious work and the most complex that she painted. She devoted more time to the perspective and made herself a model in order to understand the theory better. In the summer of 1830 she went to Ashton Court to paint Sir John Smyth's coach and four, which features prominently on the left of the finished painting. The Smyths invited her to lunch every day where she ate partridges, pineapples, hot-house grapes and other luxuries. She worked throughout the year on the painting and by the following summer she had completed the ash tree, which was included for purely compositional reasons and was based on the one outside her house.

The summer of 1831 saw the family move for the final time, to St Vincent's Parade by the river at Hotwells. They 'were much pleased with the change; it commands a beautiful view of the opposite rocks and woods, enlivened at high water by the passing of steamers and other vessels. The pictures appeared to more advantage in rooms spacious and lofty, and the rent was not quite so high. The ferry so near, we crossed almost every summer afternoon with light camp chairs, and a simple apparatus [of] Rolinda's contrivance, to

The Clifton Race-Course, Rolinda Sharples, oil on canvas 1836.

enable her in oil colours to sketch from nature. In Leigh Woods, Salvator Rosa and Nightingale Valleys how delighted we were, breathing the delicious air, and observing the beautiful picturesque scenery as it was marked permanently on the panel' (*Mrs Sharples Letters*, to Miss Pigott, April 10, 1843). Few of Rolinda's landscapes are known today, and they are of poor quality, but her interest in painting direct from nature in oils, onto the mahogany panels so much used by the Bristol School at this time, is notable. It was unusual for a British artist to use oil paints outside at this period

although there is a James Baker Pyne (1800-1870) *View of the Avon from Durdham Down*, 1829, which shows an artist painting a sunset in oils (Bristol Museums & Art Gallery).

At the end of October 1831 the Bristol Riots devastated the city. They were a particularly destructive manifestation of the general unrest in the country prior to the passing of the 1832 Reform Act and the mob's burning of gaols, toll-houses, the Bishop's Palace and Queen Square shocked the local gentry. Scapegoats were sought for the mayhem and the Mayor was put on trial and the commanding officer and captain of the dragoons court-martialled. The accusation was that they had acted too slowly in quelling the riot. Bristol society, including Rolinda, attended the court martial and she took her sketch book with her. The subsequent oil painting *The Trial of Colonel Brereton* (Bristol Museums & Art Gallery) is a large and laboured piece with about 150 tightly packed figures, many of which are portraits (including of people who were not at the trial). There is no drama or even incident and she must have completed it only through dogged determination, working on it almost daily throughout 1832-3. It was finished in February 1834 and exhibited that year in London and in Bristol. She was then at last able to return to the temporarily abandoned *The Clifton Race-Course* and friends continued to sit to her for it. The finished work was dated 1836, seven years after her first sketches, and was exhibited at the Society of British Artists as *Clearing the Course*. It is her last-known work and by far her most technically accomplished. The multitude of figures were now integrated with the landscape and her command of perspective much improved. Although her paintings lack the characterisation and social comment of the best of Bird's and E V Rippingille's work, her early death was to rob Bristol of further lively depictions of its contemporary life. Bird had died in 1819 and Rippingille and Colman both left Bristol. With Rolinda's death, there was no artist to carry on the tradition of the Bristol School genre painters.

The diary, its entries increasingly brief, ends in August 1836 when the foundation stone was laid for the Clifton Suspension Bridge. Perhaps Rolinda's terminal illness was already apparent. Ellen later wrote a long and melancholy letter to an old friend: 'I, whom, on your hearing of a death in the family, you naturally thought was no more, am still in existence, and my dear highly gifted son, and daughter, live now only in their

works' (*Mrs Sharples Letters*, to Miss Pigott, April 10, 1843). Rolinda had suffered breast cancer: '... a dark blighting cloud suddenly threw its sombre shadow over all ... that most dreadful of all diseases, a cancer ... a long and most painful illness, born with a heroism beyond human nature.' Rolinda died in February 1838, aged forty-four, and James, whose health had been delicate for many years, died just eighteen months later, probably from consumption. Ellen lived a solitary life for another decade and died at the age of eighty in 1849. She was surrounded by the family's paintings and drawings which adorned the walls of almost every room in the house at St Vincent's Parade. Her letters show how she dealt with her grief and the infirmities of old age in her usual positive way. She told correspondents that for health of body, and peace of mind, there was 'the absolute necessity of air, exercise, employment that interests, and the reading of instructive and amusing books. I perceived that the persons who thus acted were the better enabled to bear up when grievously tried...' (*Mrs Sharples Letters*, undated letter to Miss S., mid-1840s).

Ellen had no heirs, for her children had never married, and it was typical of her in her declining years to turn her thoughts to supporting the establishment of what was to become the Bristol Academy for the Promotion of the Fine Arts. 'If the Bristolians are only now liberal all preceding neglect of Art will be forgotten: an elegant edifice will arise an ornament and honour to the city which within its walls will contain a succession of the various beauties of Art' (*Mrs Sharples Letters*, undated letter to Mr M [presumably Philip Miles], c.1845). In 1845 she gave £2,000 towards the establishment of the Academy, receiving a 4% annuity on the sum during her lifetime. On her death the bulk of her estate was left in trust for the benefit of the Academy along with most of the Sharples family paintings and drawings which hung in her house. Those paintings and drawings now form the core of Bristol Museums & Art Gallery's Sharples collection, and her instructions to her executors are still attached to the backs of some of their frames. As is related elsewhere in this publication the Academy lent its collection, including nearly 100 works by the Sharples family, to the Bristol Art Gallery in 1910 and later sold the collection outright to them in 1931. Today, a selection of oil paintings by Rolinda are always on show in the Bristol School gallery at the central Museum and the Sharples family pastel portrait drawings, which are sensitive to light, can be seen by appointment. Ellen was also a fine needlewoman and the Museum has four examples of her work, all

copies of engravings worked in silk.

Although the Sharples family were not native to Bristol they had left their adopted city a generous legacy: James senior's portrait drawings of local, national and international figures, Rolinda's genre paintings based on the local life of the 1820s and 1830s, and Ellen's financial support to establish what is now the Royal West of England Academy. Ellen's diary, which makes their lives and achievements so vivid, also gives us an insight into the working practices of artists at the end of the eighteenth and beginning of the nineteenth centuries. In addition, the crucial encouragement for Rolinda's decision to make a career as an artist came from Ellen's advanced views on the education of her daughter and the early fostering of her talents. Although Rolinda could have made a conventional living from portraiture she took the decision to tackle the challenges posed by multi-figure compositions and was one of the first women artists in this country to do so, exhibiting her work widely. Today those paintings are recognised as an important contribution to the achievement of the Bristol School of Artists.

A First Exhibition

That first Academy exhibition in the rooms at the Bristol Institution, in 1845, was considered a success, although it made a small loss and failed to attract the public in any great numbers, despite the employment of boys to carry posters around the city streets. The exhibition opened on March 25th to run for three months, but was extended to the end of July.

A committee of artists had been appointed to select and hang the exhibition. It was advertised in the *London Art Union Journal*, with the Sharples Prize to be awarded for the best historical painting in oil, the size to be not less than three feet in width. Other inducements to would-be participants were prizes for a study from the Old Masters in the same scale as the original; for the best original watercolour; the best charcoal drawing; the best original drawing on stone (lithograph); the best specimen of sculpture in marble or stone; the best model in clay or plaster; and the best specimen in stained glass. The winners in each category would receive the Academy's medal. This publicity seems to have worked, as no fewer than 44 of the 109 artists who exhibited were from London, with a smattering from other parts of the country. Of Bristol artists, among the most prominent were Charles and Nathan Branwhite, James Curnock, Henry Hewitt, Samuel Jackson father and son, EG Müller, JB Pyne, EV Rippingille, James Tovey, Joseph Walter and William West.

Edwin Landseer showed *Lion and Dash, favourite dogs of his Grace the Duke of Beaufort KG*, which was lent for the exhibition by his Grace. Of 298 pictures in all, about half were in watercolour. A handful were by women. The subjects ranged widely over portraits, landscapes (including local beauty spots like Nightingale Valley and Stapleton), historical subjects and scenes from Shakespeare. Topically, among the most interesting to Bristolians would have been Joseph Walter's recently executed *Great Britain struck by the sea off the Coast of Cornwall on her passage from Bristol to London, 24th January 1845*, one of three paintings he showed of Brunel's great steamship.

There appear to have been no submissions for many of the categories for which prizes were offered; at least none was included in the exhibition.

The Committee of Management used the exhibition catalogue to promote the Academy's cause. 'The Pictures in these rooms at once exhibit a proof of the high state of advancement which the unassisted talent of the district has attained, and establish the strongest claim upon all who would foster pursuits which, while they combine mental power with mechanical skill in the highest degree, contribute to the ornament and delight of society, and to the perfection of the useful arts.'

The notice continued: '... the spring of 1846 will, it is hoped, witness the rise of a building in every way worthy of the objects of the Association, and of the wealthy and generous neighbourhood in which it has been formed.' That proved to be wishful thinking. Nothing came of the suggested purchase of part of the Institution's Park Street premises, after a withering criticism that the Academy had begun with sixty-three subscribers (as opposed to artist members) at a guinea a head, but had already, three years later, dwindled in number to just nineteen. These astonishingly poor figures were thrown into sharp relief by the success of a literary institution which opened in Broad Street in 1845, moving soon after to Corn Street where by 1850 membership had reached very nearly one thousand. Five years later, the Bristol Athenaeum could boast over 1,500 members, although this was to prove a high-water mark as dissent and debts were soon to take their toll.

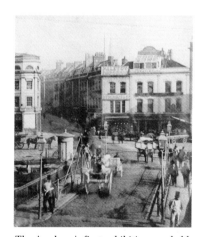

The Academy's first exhibition was held in 1845 in a hired room on St Augustine's Parade facing The Drawbridge and looking across towards Clare Street.

Wide-ranging discussions about the future development of the fledgling academy which included a suggestion for a 'coalition' between the Academy and the Athenaeum, the Bristol Library Society and the Bristol Institution proved abortive.

The Literary and Philosophical Institution, in whose premises the Academy's inaugural meeting was held, had been founded in 1808 and had moved to Park Street in 1823. It shared the building with the Bristol Institution for the Advancement of Science and Art. The one institution played a largely educational role in organising lectures on scientific and literary topics, while the other's main function was to

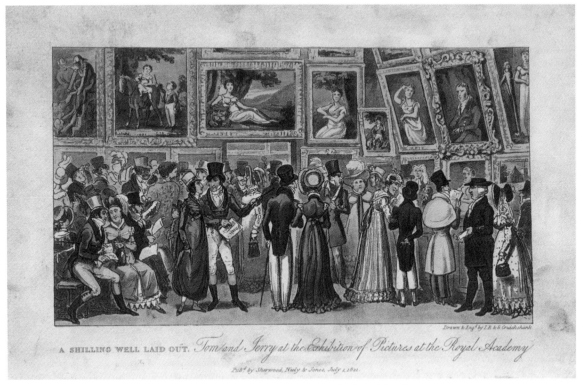

A Shilling well laid out: Tom and Jerry at the Exhibition of Pictures at the Royal Academy:
George and Robert Cruikshank's view of London gallery-goers, 1821.

establish a museum for objects of natural history, with supplementary provision for
'exhibitions of pictures, statues, casts and other objects of the fine arts and antiquities
...' The fine arts were indeed represented, and one of the Institution's early acquisitions
was E H Baily's *Eve at the Fountain*, now in the collection of Bristol Art Gallery. Initially
there were regular exhibitions of pictures in the Institution's Great Room, beginning in
1824. Works by living artists alternated with shows of Old Masters.

With a declining membership, and in some financial difficulties, the Institution later
merged with the Bristol Library Society (then housed in the Bishop's College on the site
of the present Bristol Museums & Art Gallery) in 1867. Eventually, in April, 1872, a
new Bristol Museum and Library Association opened its doors to the public in John
Foster and Archibald Ponton's striking Venetian Gothic building, which would many
years later serve as the University Refectory and later still would house Brown's
Restaurant. The new museum was not immune to the financial difficulties which had
dogged its predecessor and, bowing to the inevitable, in 1893 the building and its

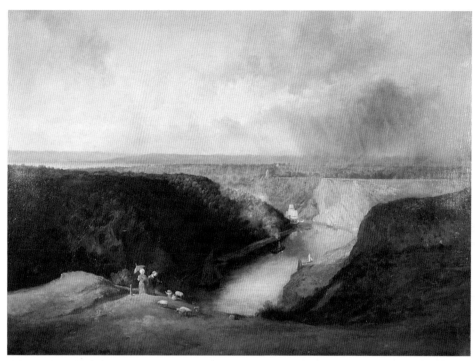

A View of the Avon Gorge from Observatory Hill, William West, oil, c.1834. Possibly the work exhibited in 1834 at the Bristol Society of Artists' third exhibition. [Bristol Museums & Art Gallery]

contents were transferred to Bristol Corporation. In 1906 the City Museum took over the whole building when the Reference Library moved to College Green to form the core of the new Central Library designed by Charles Holden. The museum itself eventually vacated the building in the early years of the Second World War, after it had been gutted by an enemy bomb, and ever since has shared premises with Bristol Art Gallery next door.

This was the chequered cultural background against which the Academy would seek to establish itself in the coming decades. After the Park Street rebuff, the Academy eventually hired an exhibition room on St Augustine's Parade, on the waterfront facing the drawbridge. This, and a later temporary letting, would serve until the Queen's Road building was commissioned. These early exhibitions were quite substantial affairs. The fourth annual exhibition, held in 1849, was billed as 'Works by Living Artists', and showed 243 paintings, mostly landscapes and seascapes, but some portraits. Of the 89 artists exhibiting, fourteen were Academy members; eight of the twenty-two artist members did not show that year. The five artist members on the Committee of

The Breaking-up of the Camp, James Curnock, oil, 1855. Curnock had exhibited a picture at the Fine Art Academy's 1853 exhibition entitled *Break-up of the Camp*, probably a smaller version of this large work, which Curnock showed at the Royal Academy in 1855. The tendency of local artists to show their major works in London was a source of concern to the Council. [Bristol Museums & Art Gallery]

Management were James Curnock, Samuel Jackson, James Tovey, Robert Tucker and Joseph Walter.

The following year, John Harford, in presenting the Academy's sixth annual report, referred to 'a pecuniary loss' on that year's exhibition, 'in consequence of which the Trustees have deemed it provident not to attempt one during the present year'. A substitute loan exhibition of Old Master paintings was a financial disaster.

Members' exhibitions were soon resumed, when financial break-even was just about achieved, 'partly due to the opening of the exhibition by gas light, the visitors being chiefly artisans and labouring classes of society, while the strictest decorum was maintained.' In 1851, the year of the Great Exhibition, there were, in addition to 166 oil paintings, a watercolour room displaying 120 watercolours and, in an architecture room, 72 architectural drawings and seven models. The architects exhibiting included S C Fripp, S B Gabriel, W B Gingell, Charles Hansom, J Harrison, H Lloyd, Charles Underwood and the firms of Gabriel and Hirst, and of Pope, Bindon and Clark. Many

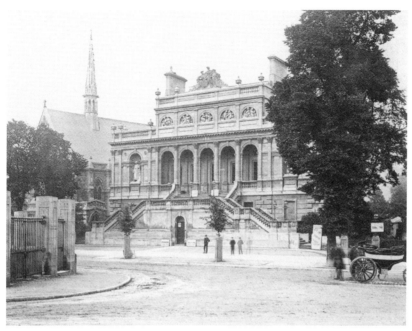

The Academy with J H Hirst's original façade.

of these gentlemen were to be closely involved in the discussions about an eventual permanent home for the Academy.

Ellen Sharples, whose generous gift of £2,000 had got the Academy off to a good start, had died without heirs in 1849, her daughter Rolinda having predeceased her in 1838 and son James in the following year. It was not surprising, but none the less gratifying to the academy trustees, that she should now leave her money, books and nearly one hundred pictures to them. This remarkable lady was laid to rest in Clifton Parish Churchyard, her funeral attended by Harford, Miles and other trustees. They had cause to be grateful, as the legacy amounted to £3,400 and serious consideration could now be given to plans to erect permanent galleries. After convoluted discussions, the consideration of various sites and the machinations of competing architects, J H Hirst's imposing Italianate façade, fronting Charles Underwood's 'block plans', was completed on a corner of Tyndall's Park in 1858.

This grand edifice facing the Victoria Rooms on the very edge of built-up Bristol – Whiteladies Road had been partly developed but most of the Victorian villas of Clifton and Redland were yet to be built in the speculative boom of the 1860s and '70s – was

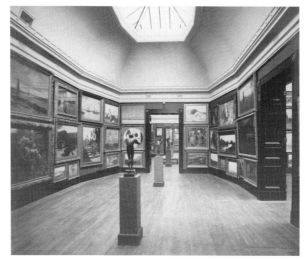

The gallery interior as it looked for many decades.

topped by a fine suite of sculptures by the noted artist John Evan Thomas. Visitors originally mounted a double flight of steps, leading to an open vestibule, an exhilarating approach which would be lost in the dour restyling of the façade in the early years of the twentieth century. Several sites had been considered, including College Green and a building at the top of Park Street, but the trustees settled on a portion of Tyndall's Park, which Philip Miles had reported could be bought for £300, discounting the objection of artist members that it was too far from the city. The Queen's Road site had been a front-runner from the outset. As early as 1845, Thomas Tyndall had been selling off building sites, subject to strict aesthetic control. At that stage, a worthy structure was beyond the Academy's means, and it was noted that 'a building sufficiently ornamental to meet the views of Mr Tyndall could not be erected under an expense of £4,000'. The story of the commissioning of the academy building is discussed in Dr Mowl's essay on page 59.

The catalogue for the great 'Works of the Old Masters and Deceased Artists' exhibition to celebrate the opening of the new building in 1858 contained the stirring exhortation by Sir M A Shee, President of the Royal Academy: 'We should look at Nature through the works of the Old Masters, using them as the telescopes of Taste, to amend our vision,

but not to bound our view.' The impressive list of loaned works included paintings by Canaletto, Claude, Constable, Cuyp, Hogarth, Leonard da Vinci, Murillo, Rembrandt and Velasquez. That year's annual exhibition, the twelfth, contained 399 works.

The Management Committee showed some imagination in trying to draw the crowds through their doors. A precedent was set by a 'Graphic Conversazione' which 'offered much gratification to our intelligent visitors', who had the opportunity of discussing the work on show with the artists in attendance. A library was started for the use of members and their friends, but was dispersed over the years particularly, it seems, during the upheavals of the Second World War when much of the Academy's archive disappeared.

The visible growth of the Academy, with all the attendant publicity, briefly brought in new subscribers, many convinced that 'the edifice would remove for ever from Bristol the stigma of neglecting the arts'. In August 1859, Academy council minutes recorded that 'the present exhibition has now been open 14 weeks and is decidedly the best yet offered to the public'. There had apparently been nearly 1,500 paying visitors. But despite this initial enthusiasm, exhibitions of members' work throughout the 1860s were poorly attended and particularly disturbing was the indifference shown by Bristol and Clifton society who, in sharp contrast, were flocking to hear readings by Charles Dickens and Wilkie Collins just across the road at the Victoria Rooms. At the annual meeting in 1863, Mr Miles pointedly observed that it seemed that 'the people of this neighbourhood do not care in the least about the fine arts'. Though there was a good collection of pictures on the walls, on his visits he always found the rooms perfectly empty. No amount of effort to bring pictures of the first class there, he concluded, seemed of any avail.

The annual report for 1867 spoke of a 'doleful' year, and to add to disappointing sales many subscribers did not renew. Local artists who sent their work for exhibition in London instead of the Bristol Academy were held to contribute to the problem, and the uneven quality of the work on show doubtless told, but the famous Bristol indifference to the fine arts was probably a more telling factor. Attendances were boosted in 1869 with 2,000 pupils from local schools, each paying one penny, helping the Academy make what was described as a 'miserable' profit of £86.

Sales improved in 1870, when a special display of W P Frith's much talked-about canvas *The Railway Station* pulled in the crowds. This was a shrewd choice, which responded to the Victorians' love of 'literary' paintings which told a story. A dealer had paid the artist big money – £4,500 for the painting and its copyright – in 1862, and later sold both the painting and print reproduction rights for £16,300. Carefully exploited, there was money to be made from Victorian art. More than 20,000 people had paid to see the picture in the seven weeks it was exhibited in London's Haymarket Gallery in 1863.

With continuing unease about the quality of exhibitions, a large collection of watercolours by J M W Turner was enlisted to support the Academy's autumn exhibition

Crowd puller: *The Railway Station*, W P Frith, oil 1862.

of 1875. This proved a success, with 2,222 'working people' at two pence a head and more than 3,000 schoolchildren again paying one penny going through the Academy doors. These attendance figures were encouraging, but couldn't begin to compare with the crowds of more than 100,000 which the local agricultural show could attract around this time.

Despite the setbacks, the exhibitions appear to have grown in size. The 1876 exhibition

of 'Works of Modern Artists' included 737 pictures, five sculptures and one architectural drawing. Prices ranged from a few guineas to the odd £50, £100 or even £150. The catalogue revealed that there were then about 250 annual subscribers at one guinea a year, and there was a list of 46 donors and life members, including the names of Mrs Sharples and the original trustees. A contribution of £25 bought life membership.

From the trade advertisements in that year's catalogue, art lovers could buy from R Howse, of 28 Park Street, Bristol, 'The Chancellor's' good sound claret at 12 shillings per dozen bottles or, for 42 shillings a dozen, a very old, finest Irish Whiskey. Old advertisements make quaint reading, but they also give a measure of comparative values. For his or her guinea a year, a subscriber was passing up the opportunity to down 21 bottles of Bordeaux or six bottles of good whiskey. Life membership cost the equivalent of 500 bottles of claret.

Two years later Robert Lang, one of the most energetic and generous of the trustees, deplored the fact that the galleries stood empty for nine months of the year. He compared Bristol unfavourably with Liverpool, Birmingham, Norwich and other cities, which held numerous exhibitions, while the Bristol Academy's galleries were being let to chess clubs and other activities irrelevant to its purposes. In those cities, it was 'not a question of 6,000 visitors but 60,000'. The Academy had not 'increased one jot in importance or in character as compared with what it was twenty-five or thirty years ago'. The position of Fine Art in Bristol was deplorable and he could not see any prospect of a revival except through the School of Art.

Stung by this criticism, and concerned about the poor attendances, the committee decided to hold an exhibition of the whole of its permanent collection of paintings, including the Sharples legacy and, crucially, to make admission free. A gratifying 15,000 people responded, but it was reported that there was a conspicuous lack of interest among the Academy's own subscribers, who perhaps had felt they had 'done their bit' when handing over their annual subscriptions. It is impossible to avoid the conclusion – as the heartening and overwhelming public response to the opening of a free municipal art gallery would eventually show – that most people would not, or could not, pay to look at pictures. It was a lesson the City Council itself was to learn a hundred years or more later when it introduced admission charges to the City Museum and Art Gallery,

Bristol Harbour, William Matthew Hale, oil. [RWA Permanent Collection]

softened by the issue of a 'leisure card' for local residents, only to find that the number of visitors plummeted as a result. That experiment, in the early 1990s, prompted one local journalist to fulminate about the iniquity of having to pay a couple of pounds a year to give him and his family unlimited access to the city's treasures. Although that over-reaction was an extreme case, it highlighted an ill-conceived plan which caused much resentment among local people.

On the death of the stalwart Philip Miles aged 65 in 1881, Samuel Lang – Robert's brother – was elected President. Like his brother, he was scathing in his criticism. 'I do not think that Clifton or Bristol people realise the value of their subscriptions,' he thundered, adding that there were many wealthy Bristolians, including mayors and aldermen, who had given much to charities, but little or nothing to Art. 'There is no love of Art in Bristol,' he concluded. His strictures were fully reported in the local press, prompting the then Mayor of Bristol, Joseph Weston, a noted collector of the work of W J Müller, to rush a cheque for £50 to the Academy as a gift towards the permanent

collection and a future picture gallery for the city. In 1882, Robert Lang returned to the attack, telling a sparsely attended meeting that the Committee had tried year after year to get up a fund to buy pictures, but the results, he said, had been pitiful. More recently, he had endeavoured to acquire for the Academy some of the late Charles Branwhite's pictures, but the sum offered by members was so ridiculous that he was forced to abandon the project.

The pessimism which permeates the minute books of this period was underlined by the resignation of both Robert and Samuel Lang, who served just three years as president. But other members of the committee were more sanguine and gave their unstinting support to the artist members, their life drawing studio and the School of Art itself. The City Council as a body continued to cold-shoulder the academy on the hill but there was a body of liberally minded and generous men and women willing to give their support and money. All the while, the committee could not be faulted for effort. The winter of 1889-90 saw a series of four classical concerts which appear to have been financially successful, as they continued to feature in the Academy's calendar for some years. The last decade of the nineteenth century saw the old Graphic Conversazione converted to a

Stanhope Forbes, seen here painting in Newlyn, was recruited to Academy membership.

Graphic Soirée, when artist members showed sketches while refreshments were served. These occasions proved popular, among lay members and artists, but formal exhibitions continued to be poorly attended, and sales were disappointing.

These continuing poor attendances gave added weight to the growing demand for a publicly run and free-to-enter municipal gallery such as an increasing number of major provincial cities could now boast. The Academy's permanent collection was rarely put on show, reviving the old question: what was the primary purpose of the institution: to provide a school of art and encourage and assist local artists or to act as the city's prime exhibition gallery? It was a dilemma compounded by the Academy's collection being augmented by gifts of paintings and other works of art and the subsequent vocal demand for their exhibition. Various proposals for a municipal take-over were mooted, and strongly resisted by the artist members.

To stimulate interest, the Academy offered admission at special rates. Under an arrangement with the local trades council, worker members could attend exhibitions at a reduced price of 2d, and anyone buying an Art Union lottery ticket would be let in free. Other steps proposed were for free admission on certain days, and some form of permanent collection to be held 'in some poor neighbourhood such as St Philips or Bedminster'.

A pamphlet put out in 1898 showed the Academy's resolve to broaden its appeal in a city still without a municipal gallery. The public were reminded that 450 works were shown at the spring and winter exhibitions and that 'but for these exhibitions Bristol people would have no opportunity of seeing in Bristol any good collection of pictures'. Not only this, but during the rest of the year the Sharples collection and other donated works were now exhibited free of charge three days a week.

Other steps were being taken to make the Academy more popular. Exhibitions, it seems, were then normally open from nine in the morning until six o'clock in the evening but on Wednesdays and Saturdays the Academy galleries would remain open until nine o'clock. 'The subjects of many pictures are drawn from history or ancient stories, which are not matters of everyday knowledge, and such pictures give greater enjoyment and are much more interesting if an explanation can be got'. On Saturday evenings, therefore, artist

A Fish Sale on a Cornish Beach, Stanhope Forbes, oil 1885. [City of Plymouth Museums & Art Gallery]

members would make themselves available to conduct parties of 25 to 30 working men or women around the exhibition to 'explain [the pictures'] special qualities and point out those beauties which are not always instantly seen'. Local trade unions organised groups of members to attend, and the conducted parties proved a great success.

The visual arts might be struggling for recognition in Bristol but further west, in Newlyn and St Ives, the new realism was all the rage and making a major impact in London, where Newlyn School paintings such as Stanhope Forbes's celebrated masterpiece, *Fish Sale on a Cornish Beach* of 1885, were beginning to feature strongly in the Royal Academy's summer shows. The Body of Artists saw this phenomenon as a means of raising the status of the Bristol Academy and the quality of work shown there. So, in the closing years of the century, a number of artists working in Cornwall were invited to apply for membership. Those elected included Stanhope Forbes himself, TC Gotch, C Napier Hemy, Julius Olsson and Adrian Stokes.

This was an imaginative and timely move. Bristol would be an important exhibiting city

Another recruit from Cornwall, Lamorna Birch headed the Academy's hanging committee in 1922.

for many Newlyn and St Ives artists for years to come. The artist Lamorna Birch visited Bristol in 1910, returning to Cornwall on February 19 with a formal invitation in his pocket to apply for membership of the Bristol Academy. 'It appears that I am looked upon as a small god in the art world here,' he told a friend. 'In particular, they seem greatly pleased with my water paintings,' adding, 'though I am feted on all sides, I'm afraid there is no money in it.' Birch's links with Bristol continued for many years, and in 1922 he was invited to take charge of hanging the autumn show. This expansion in the Academy's sphere of influence to take in artists throughout the west was reflected in the change of name when, in 1913, it was granted royal status.

The Academy in its early years.

Battle of the Styles

The Bristol Academy of Fine Arts wasted no time in laying plans for a permanent home, though it would be more than a decade before they opened their own doors to the public. Within two months of its foundation, a sub-committee had been formed 'for the purpose of conferring with Mr Dyer, Architect, relative to building on the site proposed, without pledging the Committee to employ that gentleman in erecting the intended edifice'.

Charles Dyer was the son of a Bristol surgeon and has the singular distinction of having signed most of his best buildings as if he craved public recognition. His most impressive building in the city is the Victoria Rooms, opposite the eventual site for the Academy. Dyer's early scheme may have been promoted by Henry Bush who was on the artists' management committee and for whom Dyer had built Litfield House on the Promenade in Clifton. This was the beginning of a long campaign by Bristol's architects to gain the prized commission of designing a new Academy for the city.

However, a letter from the London artist and art critic, Charles Lock Eastlake (later to become President of the Royal Academy), which was read to the meeting on July 19, 1845, was designed to scotch the idea of a new building. Eastlake advised against spending money on such a venture before the artists had been properly established in the region. But this did not stop the City Surveyor, Richard Shackleton Pope, from proposing a site and submitting 'two Architectural elevations' to the Committee in December of that year. This was not pursued as the site was thought to be too expensive.

Over the course of the next three years further proposals for sites and new buildings were discussed but dismissed until the committee's meeting of August 26, 1848, when a letter from Pope was read explaining his plans and 'elevations of a building he offers for a certain sum to erect for the purposes of the Academy'. This obviously caused a stir among the Bristol architectural fraternity, as Pope, who was tied to the Corporation as

Surveyor, was not a popular man. The same meeting heard another letter from Samuel Charles Fripp which was counter-signed by five other architects, proposing that the design of the new Academy be 'thrown open to competition amongst the Architects of Bristol'. This would ensure that Pope did not exert his considerable influence on the Town Council's Improvement Committee in suggesting preferred sites and submitting his own designs for the new building.

Nothing further was done about holding a competition, but by 1850 the Academy had proved its stability and began to think again about a new building to reflect its civic ambitions. Crucially, Academy funds had been boosted by the £3,400 left to the trustees by Ellen Sharples on her death in 1849. A new academy building with galleries could house an art school and even possibly a city library: a project which could affect land values all over Bristol and Clifton. For some time now the successful architects of the city had realised that they were missing out on this potentially very influential body, one which might decide, not only the stylistic direction of future building, but to whom the commissions should be given. Then there was the matter of aesthetic status. Were not architects also artists and, therefore, natural members of such an academy?

Accordingly, on April 3, 1850, they set up the Bristol Society of Architects. This had, on paper, an imposing hierarchy of fellows, graduates and the associates who were chiefly local builders, students and corresponding members. In practice the fourteen Fellows would take the decisions, guided by a sub-committee of six, only three of whom were required to make a quorum. John Henry Hirst, the future designer of the front elevation of the Academy building, was one of the first six, as was Charles Underwood, who would later be responsible for the galleries and interior of the Academy. Another of the elite six was Pope; he and Underwood were the new Society's two Vice-Presidents, but Underwood almost invariably chaired meetings. As their President the architects would tactfully choose, in 1852, John Scandrett Harford, the rich banker of Blaise Castle House, who was also, not coincidentally, President of the Bristol Academy of Fine Arts.

The architects' first major initiative was, significantly, to propose in April 1850 that their Society should link up with the artists to share joint membership of the Academy. Daringly they suggested in July that no fewer than five architects should serve on the Academy's powerful management committee. The artists politely rejected this obvious

take-over bid from the junior Society, offering instead places for five Fellows 'in the general body of Artist members', a mere token presence in a body which met infrequently, and then only to rubber-stamp decisions made by their Management Committee. The architects replied proposing that all their Fellows, at that time fourteen in number, be admitted to this lowly 'general body'. This counter-proposal was turned down out of hand and the Academy's grudging terms, allowing seven Fellows into their membership, were accepted by the chastened architects as an interim bargaining position.

Seven Fellows were elected, Underwood and Hirst among them, and negotiations continued. At a meeting on March 10, 1851 better terms were announced. All the Fellows of the Bristol Society of Architects could be admitted as 'Artist Members of the Academy', seven could become voting members of the artists' general body, and one of them could 'act as a representative of the Society of Architects on the Committee of Management'. This was better than nothing. At least it offered a foothold and a voice in the councils of the beloved enemy. Finally, on April 26, the link between the two bodies was effected and the contract was signed by Harford and Underwood. Harford was then approached to become President of the architects and the artists agreed that this would be appropriate.

At a distance of 150 years it is difficult to understand the eagerness of the architects to accept such terms. In today's world, artists might be just as likely to want to infiltrate architects, but this was the age of Prince Albert when the arts had a huge prestige and were seen as having a civilizing mission to the nation. The Prince had been approached to be a Patron of the Bristol Academy as early as January 1845, and he accepted this honour in the following October, sending a £25 donation the following month. The architectural magazine, *The Builder*, regularly carried reports on the meetings and exhibitions in the regional Schools of Art. There were thriving schools in Sheffield, Birmingham and Newcastle, and in the West Country similar institutions in Devonport, Plymouth, Torquay, Exeter, Taunton and Wellington. By 1858 there would be no fewer than sixty-nine schools of practical and fine art throughout the country educating 35,000 students in painting and drawing, and in the same year the government began making grants 'towards the erection of buildings for Schools of Art'.

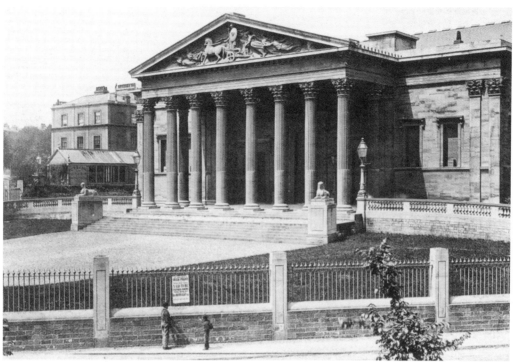

Charles Dyer's Victoria Rooms of 1839-41.

In Bristol the 1850s was a decade when the choice of architectural styles was delicately balanced and change was in the air. The city had clung conservatively to neo-Classicism for its domestic and some of its civic buildings longer than most British industrial centres. An austere Grecian classicism prevailed, chastely incised but not heavily ornamented except with the conventional orders. Dyer's Victoria Rooms of 1839-41 was a powerful presence near one of the proposed sites for the Academy. Such architecture depended upon a good, close-grained limestone ashlar for its effects. Clifton had been and still was being built in that style, and Charles Underwood was an acknowledged expert in its handsome austerities. His fellow Vice-President, RS Pope, was ready to design in classical or Gothic, but he was not popular with the other Fellows and on April 5, 1852 he would be obliged to apologise for speaking about his professional associates as 'a blackguard Society'.

The stylistic innovator and enthusiast for experiment in eclectic styles among the Fellows was William Bruce Gingell, but he would resign from the Society of Architects angrily on

August 30, 1853 over criticism of the way he had secured the commission to design the General Hospital on the Bathurst Basin. That was a round-arched 'Rundbogenstil' design, pitch-faced with extensive use of Pennant sandstone. Pennant was a coarse-grained stone, much cheaper than Bath or Dundry limestone because its quarries were near at hand on Blackboy Hill. A style, therefore, which could use Pennant for major elevations would have economic attractions; aesthetic preferences and profits were closely linked.

In 1851 Underwood had begun Worcester Terrace, Clifton, in a Greek Doric purity so ruthless and repetitive that its houses were not selling well. A little to the south of it John Yalland's south-west side of Victoria Square was going up in a sumptuous Italian palace version of the old-style classical terrace, with round-arched bifora windows in a committed Rundbogenstil. Styles were shifting, the old tried and tested neo-Classicism was no longer appealing, and the actual styling of the new Academy building was likely to direct taste in the city. The Society of Architects' minute book for 1850-5 is, consequently, of great interest as evidence of the current stylistic debate.

Houses in Charles Underwood's Greek Doric Worcester Terrace were not selling well.

Victoria Square: styles shifting away from the neo-classical. [Photograph: John Trelawny-Ross]

On March 31, 1851 John Hirst contrived to get himself elected Secretary of the architects' society. This was the signal for a copious flow of minutes with much clarification of rules and fines and a rush of Monday 'Ordinaries' when Fellows gave improving lectures. At this time the Society had no proper base, renting rooms in 1 Trinity Street and hinting that they might share the artists' equally temporary premises. The new Secretary, however, was angling to design the Academy's permanent home,

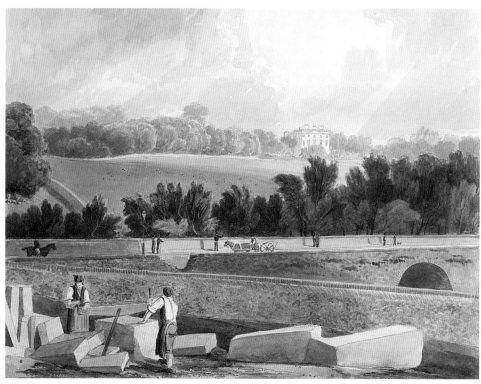

View from Park Place across Whiteladies (now Queen's) Road to the Royal Fort. [Bristol Museums & Art Gallery]. The Academy's building would be erected a few yards to the left of Samuel Jackson's watercolour painting of 1824.

which could settle that problem. In August 1852 it was proposed that every Fellow should offer, without charging a fee, a rough outline design for the Academy. After discussion of these, one design would go forward, the Academy would shoulder the building costs, but the architects would 'superintend the execution of the work and every other matter or thing appertaining to the province of an Architect'. When they read this the artists* nervously asked for clarification. Soothing reassurances were offered in September and from a letter, written much later, on April 11, 1854, by the joint President of the two bodies, John Scandrett Harford, it appears that back in September 1852 he had been shown a Greek Revival design using the Ionic order from the Erectheion at Athens which he liked. There is no mention of this design in the 1852-3 minutes so Underwood may have surreptitiously stolen a march on his fellow architects.

That could explain a letter of October 25, 1852 in which the Fine Arts Committee of

*In practice, the artists as such probably had little say, as it was the lay members who effectively ran the Academy.

Management told the architects that, 'the Greek Ionic of the Temple of Erechtheus at Athens is the Order which it is their unanimous wish should be adopted in the intended building'. So, in the artists' eyes, Greek Revival was the only option at that time. By now the artists had decided to buy a plot of land on the Tyndall's Park Gate site immediately opposite the ostentatiously classical Victoria Rooms. They had promised 'a building sufficiently ornamented to meet the views of Mr Tyndall', from whom they had bought the plot, and an Ionic-columned Academy would provide a visual counterpoint to the Corinthian-porticoed Victoria Rooms across the road.

John Henry Hirst would have to work fast if he was to arrest this stylistic momentum. At the Monday Ordinary of November 1, 1852 the Secretary took the initiative, when he

> gave a description of the following Picture Galleries which he had personally visited during a recent tour of Berlin, Dresden, Vienna, Munich, illustrating by sketches, and presented to the Society a Book of plans, Elevations, Sections & details of the 1st Pinakothek at Munich erected under the superintendence & from the designs of Herr Ober-baurath von Klenze ... A lively discussion followed.

Germany in general and Prussia in particular were modernizing forces in education and the arts and Hirst had obviously impressed the Fellows with his superior knowledge of the leading gallery builders of Europe, the Germans. The fenestration of Klenze's 1826-36 Alte Pinakothek at Munich is, on its first floor, similar in articulation, though with Ionic columns, to the Corinthian first floor of what Hirst would design for the Bristol Academy. Pressing home his advantage in March 1853, Hirst ordered for the Society two periodicals, the 'Zeitschrift fur Bauwesen', published in Berlin, and 'Forster's Allgemeine Bau-zeitung', also proposing successfully that 'Herr ober-Baurath Busse of Berlin, principal director of the Prussian Academy of Architecture' should become a Corresponding Member of the Society. There had been, apparently, no discussion of contemporary structures for the fine arts in London, Edinburgh or the northern industrial cities in England. As far as Bristol's architects were concerned the Germans were the leading nation in the field and, when the impressive galleries of the German states and of Austria, as they existed before the bombing of the 1939-45 war, are considered, it is hard to disagree with them.

Having effectively sown the seeds of controversy Hirst came to the end of his two-year term as Secretary. The minutes immediately became shorter and failures to achieve quorums for meetings became quite common. Whole pages passed without entries. Then, on April 11, 1854, President Harford wrote to the architects firmly advocating the Greek Ionic style for the new Academy building as 'proposed in Sept 1852'. He continued:

> I remember thinking that the general scheme of the Façade which you placed before us at the time above referred to was very pleasing and I hope it will not be materially departed from. The order of Ionic to which I refer is obviously peculiarly graceful. I think the Tympanum should be adorned by a portion of the restored Elgin frieze which is to be had in London. Should you wish to confer with Mr Miles and me at any time upon the subject of this note pray apprize me.

Philip Miles was the Vice-President of the artists' Academy and he would play a leading role in future stylistic decision making. Implicit in Harford's letter is the suggestion that an alternative scheme was afoot and that it should be pursued no further. By the end of May rough sketches for the proposed Academy had been received from Pope, Edward Gabriel, Hirst, S C Fripp and Henry Masters; 'upon which it was determined that the Portico should be designed with six columns in front and that its floor shall be on the same level as that of the Victoria Rooms....another meeting be held on this day week for the further consideration of the subject'.

So as late as May 1854 the architects were apparently still intent on a modern 'Athenian' space at the top of Queen's Road with the Corinthian Victoria Rooms echoed by the Ionic Academy: a harmonious, conservative Greek Revival solution which could have made Bristol the Edinburgh of the west. After that, the mists of an obscure conspiracy close in. On June 9, Charles Hansom and Gabriel were appointed to consider the plans and report to Underwood; but on July 4 Hirst proposed receiving 'Mr Fripps and Mr Lloyds plans for the Fine Art Academy or from any other member and to finally decide upon communicating with the Fine Arts Academy upon the designs sent in'. This motion was carried, though it was the last time on which the Fripp and Lloyd design was ever mentioned. That joint meeting between the two bodies took place towards the end of the month, but the architects were then asked by the Committee of Management of the

Academy to report on the designs with costings. So the artists would still have the last word.

At a meeting of the Council on December 4 with Underwood, Pope, Welsh (ST Welch), Hansom, Fripp, Hirst and John Bindon present 'it was agreed that the designs prepared by Mr Underwood in the Classic style of Architecture and that by Mr Hirst in the Italian style be recommended to the Society of Artists as embodying the ideas of the Architects Society'. Until this point there had been no mention of an Italian-style scheme. A further joint meeting of artists and architects was suggested while Welsh and Hansom proposed 'a Committee upon the proposed new Building for the Artists Academy and that three form a quorum'. After that sinister suggestion of a stitch-up a curious silence descended upon the debate. Compromise was in the air. Fripp had, unusually, chaired the meeting.

There was another factor, the Gingell factor, which should be born in mind in this stylistic tussle between Underwood and Hirst, artists and architects. Throughout 1854 the designs which Gingell, the wild man of Bristol's style wars, had prepared for the new West of England and South Wales Bank in Corn Street were being appraised in design circles. Even now, as Lloyds Bank, it is a building to catch the eye and then hold the attention. It represents classicism projected, by the depth of its arches and windows, far beyond two-dimensional façadism into a near-Gothic three dimensions. Gingell had taken the elevation by Jacopo Sansovino for the Biblioteca Marciana in Venice and relied upon the furious energy of the sculptor John Evan Thomas to literally plaster the façade with more and richer carvings to keystones, frieze and spandrels than even Sansovino had ever dared. As yet there were only foundations and a basement in Corn Street, but this was a building to delight the Victorian middle class; this was the way ahead for Bristol: classicism galvanized into a Ruskinian profusion of sculptural invention. Cross Gingell's bank with that first-floor fenestration of the Alte Pinakothek and cram it all into an approximation of the façade of the Palazzo Barberini in Rome and John Hirst had his Academy design. How could artists resist an offer that included so much remuneration for sculptors?

The proposals which Gingell and his partner, Thomas Royce Lysaght, had put forward for their bank included symbolic carved compliments to Bristol, Bath, Exeter, Newport,

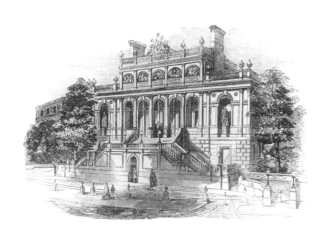

An early engraving of the Academy (above) and the stylistic comparison with W B Gingell's West of England and South Wales Bank in Corn Street (below).
The sculpture for both buildings is by John Evan Thomas.

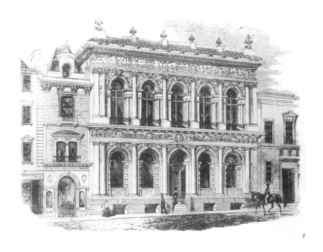

Cardiff and four English and Welsh rivers. Justice, Integrity, Education, Charity, Peace, Plenty, Art, Science, Navigation and Commerce would all be celebrated by the poses of the hyperactive cherubs on its frieze. Gingell had the formula for success and Hirst was a willing learner.

To turn from the minutes of the architects' meetings to the minutes of the artists is to move from competitive tensions into genial calm, and much is explained that was previously obscure. The biggest surprise is to find Charles Underwood, the ever presiding chairman of the architects' meetings, equally, if not more prominent, at the gentlemanly proceedings of the artists. Underwood was first welcomed officially to the proceedings of the artists' Management Committee by Harford at a meeting on February 10, 1852, so he was the fortunate chosen one of the five architects allowed into the inner councils of the Academy. Sites for the new Academy building were still being discussed. There was one at the top of Park Street which Pope, Underwood's rival and co-Vice-President, favoured, another on College Green, and a third, the most remote from the old city centre, at Tyndall's Park Gate. At their meeting on March 2, the Committee put Underwood onto a sub-committee to decide on these three sites. Five days later, against opposition from artist members, the Tyndall Park Gate site was chosen; Underwood, who built villas in that area, can be assumed to have lobbied for it. In June he laid plans for the new building before the Committee at a session in which a last attempt by Pope to sell the Park Street site to the

Academy was rejected: a clear Underwood victory.

He followed up his success on August 12 with more plans 'according to his own ideas based upon information furnished by the Artists'. Philip Miles, the Vice-President, who tended to chair the artists' meetings alternately with Harford, proposed that Underwood's plan 'should be the basis of the design supplied by the Society of Architects'. Underwood had thus become virtually the official architect for the project, all behind the backs of the architect Fellows. It was on September 9 that the letter to the Fellows urging that 'the Greek Ionic of the Temple of Erechtheus at Athens' was the unanimous choice of the artists, was sent. Harford was in the chair on that occasion, which clearly suggests he was committed to it.

At the AGM and Viewing Day, two days later, Harford reported that an un-named 'member of the Bristol Society of Architects has favoured your Committee with an elegant design'; so Underwood must have thought he was home and dry, with the matter settled to the artists' satisfaction. It is interesting that in their Annual Report of that day, September 11, 1852, the artists congratulated themselves on the numerous visitors to the viewing, 'chiefly of the artisan and labouring classes of society, great interest appeared to be excited; the strictest order and decorum prevailed', and apparently surprisingly, 'not the slightest injury was done to any of the pictures'. The Academy was considering forming a School of Industrial Design, such as Dublin had supported for a century, in addition to its School of Art. But the comment illustrates the gap in perceptions which still existed between the middle and the labouring classes in England. There were already eighty such drawing schools in France, and in Bavaria alone thirty-three, yet the Royal Academy's venture in that direction in London failed in 1839 after just two years. It would be another two decades before the Slade School of Fine Art was established in 1871 to provide a more enlightened learning environment for art education than that at the RA.

At least Bristol's art establishment was thinking positively; learning and instruction in art with a practical application were important issues. It was Pope, incidentally, not Underwood, who was pressing for a degree course to be set up in architecture. But Underwood was responsible for setting before the artists' Committee, on December 22, 1853, block plans for a proposed 'junction of the Academy and the City Library'. This

forward-looking scheme was, however, abandoned the following March, even though it would have been 'highly honourable to the City of Bristol and greatly promotive of the best Interests of Literature and the Fine Arts'.

In March 1854 the artists' Committee had more immediate matters to discuss. They officially requested the 'Chairman' of the architects Society, Underwood, 'to prepare plans for the New Building', the cost 'not to exceed £3,500'. The School of Art was to cost £1,000 and both Societies would have 'the power of additions' afterwards in the rear of the building. Two rooms, one fifty foot by thirty, the other thirty foot by twenty, with cloakroom and WC could house the School of Art down in the pit created by extracting the building stone. Underwood was officially honoured by the President as an 'amicus curiae' and asked to be present 'during discussions respecting the future building': he would, therefore, be virtually the artists' voice in such debates. An attempt by the architects to appoint Philip Miles as their new President in succession to Harford was foiled by reference to the constitution which required both societies to be presided over by the same man.

At the next meeting of the Committee in early December Miles, the artists' Vice-President, not Harford the Ionic enthusiast, was in the chair. That may explain the remarkable compromise which was effected against all previous expectations. Underwood and Hirst were both present and laid out their separate plans, 'that by Mr Underwood being Greek Ionic; and that by Mr Hirst being Italian'; Underwood's costed at £4,500, Hirst's at £6,000. 'Both designs were carefully examined by the Committee, and greatly admired'. It was ordered that they should be laid out for inspection by members of the Academy.

A month later, with Harford this time in the chair, a deal had been struck, but Harford declined putting it to the meeting personally. Instead he asked his Vice-President to explain the proposal 'as chairman of the last Meeting'. Then both Underwood and Miles introduced the plans and 'it was eventually decided, in accordance with the opinion of the meeting that the general features of the elevations produced by Mr Hirst be adopted...but that the Block plan of Mr Underwood be applied to Mr Hirst's façade', and Underwood's plan 'be appropriated to the school of Art' on the ground floor. The President, making no mention of the about turn, taken against his own clearly expressed

wishes, declared the artists' sense of obligation to the architects for 'the harmonious cooperation in forwarding the views of the Committee'.

One explanation for the strange *volte face* is that Miles was as hostile to Harford in the artists' camp as Pope was to Underwood in the architects'. It is possible that Harford had prompted the constitutional experts when Miles was up for the Presidency of the architects and so foiled his bid. There does seem to have been some resentment in Harford's handling of the final decision, as if Miles had acted when Harford's back was turned. If that is true it would be an irony as Miles, although having inherited King's Weston House in 1845, must have had a great attachment to Leigh Court, a notably Ionic, Greek Revival house built by his father in 1814, and he might have been expected to favour the order. The Academy's Committee members, made up of artists and businessmen, emerge from their minutes as a most uncritical crew, delighted by whatever design was set before them, Ionic or Italianate. Some years later in 1856, when presented with a 'Talbotype' of John Evan Thomas's proposed centrepiece for the façade, an early instance of Fox-Talbot's photography, the artists' Committee instantly approved the composition to be executed without delay. There is never any sense of a confident Bristol school of aesthetic standards developing. Was this a representative profile of provincial Victorian England's art establishment?

The final design for the 'Fine Arts Academy and School of Art' was published in a pamphlet of March 2, 1855, which stated that work would soon begin on the 'long deferred Building in the Park', and a water-colour perspective of the new building was painted by the two architects for inspection by the Academy members. A building team was approved in September with their estimates for the work. Mr Thorn, the Mason, had estimated £1,990, tactfully just under £2,000, and Mr Harris, the Carpenter, estimated £1,098. The estimate for the entire work was £3,976.3s. Underwood and Hirst were to be regularly in attendance, usually with Miles in the chair. By December 1, Hirst was exhibiting designs for 'a group of figures' to be carved by John Thomas for the front elevation. This means that Hirst must have made the initial contacts with the sculptor, possibly following an introduction from Gingell. At the next year's AGM on May 1, 1856 much was made of Thomas's connection with the sculpture on the Palace of Westminster, and an appeal was made for the additional £230 which would be needed to pay for this

carving. The President looked forward confidently to meeting next year, 1857, in the completed Academy, an edifice which 'removes for ever from Bristol the stigma of neglecting those Arts which are the result and the evidence of a high state of civilization'. It would, in fact, be 1858 when that first meeting was held.

Since the alterations of 1912-13 the binary nature of Hirst and Underwood's Academy building has not been as apparent as it was when it was first completed. Hirst's double staircase up to the first floor served to leave the 'School of Practical Art' quite separate on the ground floor with its own distinct entrance. These minutes make it clear that it was a separate body and that its premises would cost £1,311.7s3d of the final bill.

It is perhaps regrettable that Underwood's Greek Revival design was not built, as the visual impact of the Corinthian portico of the Victoria Rooms set at the same base level as the Ionic portico of the Academy, would have pulled together that rather incoherent junction of roads which today tends to focus on the forlorn figure of the Boer War veteran with his rifle. As first built, Hirst's Academy did have a much livelier dimensional depth; its double staircase, an invitation to all except the infirm, would have brought John Thomas's lunettes in the blind attic into the visitor's perspective, and those five open arches would again have offered both plastic depth and shelter. The President's wish to have the Elgin Marbles frieze in restored replica on the outside walls was disappointed, but at least they featured in plaster on the walls of the two main galleries. The casts had been donated to the Academy by Robert Lang in December 1851 and, significantly, the same casts feature in the staircase hall at Harford's Blaise Castle House. The excellent natural lighting of these galleries is witness to the readiness of the two architects to learn from the first lecture given at the Monday Ordinary, back in November 1852, when Mr John Bindon lectured on 'On lighting rooms for exhibiting pictures' before Hirst presented his impressive expertise on the superior galleries of Germany. When criticizing the accommodation of Bristol's Academy it should be remembered that when it was opened, with a gala exhibition in 1858, the Royal Academy in London was still skulking in some borrowed rooms of the present National Gallery building on Trafalgar Square.

Edinburgh, predictably, had done much better. W H Playfair's grimly magnificent Royal Scottish Academy building in a squat, ground-hugging Greek Doric order had gone up

in two stages, in 1822, and then, when it was found too small, in 1831. Playfair had troubles with extensions to an essentially complete Greek temple structure. Bristol's artists would have fewer. From the start it was intended that when more galleries or teaching spaces were required they would simply be added in the quarried pit at the back. It was a lazy solution, but probably one inherent in the first Underwood-Hirst compromise. In that original T-shaped Academy, Hirst's western façade was the top stroke of the T. Virtually anything could then be added behind it. Underwood's plan for the School of Art in the ground floor was an entrance and hall in the centre with a teaching room on the left and a ladies' room and a master's room on the right. Behind the hall, as the bottom stroke of the T, was the large, fifty foot by thirty foot, teaching room with basement premises below. On the floor above the School was the artists' Academy with three galleries, the largest, the Sharples Gallery, set in the centre directly over the main teaching room of the School of Art.

Homage: the sculpture of Sir Joshua Reynolds by John Evan Thomas.

Hirst's frontispiece was impressive but impractical. Its only windows were recessed in shadow behind those five arches of the loggia. All the rest was in effect a showcase for John Thomas's sculptures, all cement castings to cut costs, with Architecture, Painting and Sculpture symbolized at the top with smaller busts of Raphael and Botticelli. John Flaxman, the sculptor and Sir Joshua Reynolds were placed in the flanking niches below, and Thomas's favourite symbolism of hard-working cherubs in the lunettes of the attic storey. Proposed statues of Christopher Wren and Grinling Gibbons, for niches at the ends of the arcade, were never installed. The *Bristol Mirror and General Advertiser* reported on September 5, 1857 that 'the ornaments are appropriate, and whilst paying particular attention to a practical and useful arrangement of the whole, the managers have been careful to throw around ornaments of chaste and artistic beauty'.

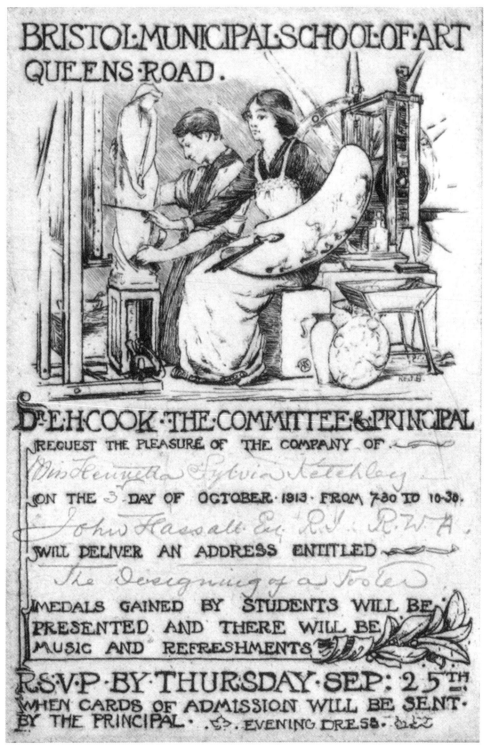

Invitation card, Reginald Bush, etching 1913.
[except where indicated, all illustrations in this chapter: Bristol Museums & Art Gallery]

Art School

From the outset, providing education in art appreciation and practice was a primary aim. Mrs Sharples' initial contribution of £2,000 was seen as a means of ensuring 'the raising of a School of Art'. Philip Miles, in expressing this sentiment, was consciously or not echoing the thoughts of William Hogarth who had written that there should be a School of English Artists and that private benefactors were most likely to fund their training.

Within a year, a 'Life Academy' was in business, offering life-drawing classes at a shilling a session in the Victoria Rooms under the tutelage of Mr M Holmes. It was an egalitarian regime, with the first female student, Miss Marian Moss, being admitted in January 1849. A Professor of Anatomy was appointed around this time, his lectures held at the Bristol Medical School being well attended by Artist Members as well as students.

The Great Exhibition of 1851 provided a nationwide impetus for formalised training of artists and craftsmen to compete with continental Europe in the design of consumer and industrial goods. In Bristol, a meeting chaired by the Mayor considered the formation of a School of Design on the lines of the Government's School of Practical Art in South Kensington. Philip Miles, as the Academy's Vice-President, became chairman of the Academy School of Art's committee, the school formally opening in November, 1853 under the title of the Bristol School of Practical Art.

Reflecting the importance attached to such training by the Government, its first master, Robert Ferrier, was appointed by the Board of Trade. Sixty-eight students enrolled in the 'artisan class' and there was a day class for ladies. To help the finances, Ferrier also offered instruction to local school children, and Clifton College was one establishment to take advantage of this. Further capital was raised by the issue of £5 shares, giving investors the opportunity to nominate students. The curriculum was based on that of the South Kensington model designed by Richard Redgrave which required students to

progress through more than twenty stages of study and practice.

Robert Ferrier was succeeded in 1862 by Mr J Hammersley, who served for just three years and then, from 1865, Mr J Nicol Smith was the incumbent for an apparently uneventful thirty years. By the end of the century, expectations were higher and the School not only needed more space but recognised that it could not afford to expand and improve its facilities without outside help. After protracted negotiations with Bristol Corporation – not helped by legal complications (the School inadvertently almost conveying property it did not own) – Bristol Education Committee took over in 1904. The School became the Bristol Municipal School of Art.

By then Reginald J Bush had been principal of the art school for nearly ten years. Bush instilled new life and increased pupil numbers to the point at which, when he retired in 1934, the Municipal School of Art was widely recognised as one of the best art schools in the country. Several notable etchers studied under Bush, including Stanley Anderson,

Book-plate for the Bristol Savages, Reginald Bush, etching 1913.

Malcolm Osborne, Nathaniel Sparks and Dorothy Woollard. Another significant etcher in that golden age was E Willis Paige, who came to Bristol in the 1920s as Bush's assistant principal and was still teaching at the art school in 1950. He was said to have been bitterly disappointed that he did not succeed Bush on his retirement in 1934.

Reginald Bush had been born in Cardiff in 1869 and trained at the Royal College of Art in London, where he taught for a year before moving to Bristol in 1895. Like others at the Municipal School he became a member of Bristol Savages, the all-male artists society which had been set up by Alfred Wilde Parsons, Ernest Ehlers and friends in 1904. There was much inter-action between School, Academy and Savages, and the work of that notable coterie of print-makers is well represented in the collection of Bristol Art Gallery, whose curator regularly bought from RWA and Bristol Savages exhibitions. Many of these works were reproduced in *City Impressions: Bristol Etchers 1910-35*, in which Sheena Stoddard wrote:

Reginald Bush's teaching and the staff he gathered around him at the Municipal School of Art are particularly important ... They were not the avant garde but all were good, traditional etchers working in the established styles of the nineteenth-century revival ... It cannot be claimed that there was a distinctive Bristol school of etching [in the 1920s] but rather that the thorough teaching of Reginald Bush launched some artists on national careers and that other, lesser artists were inspired by the quality of work exhibited by him, his colleagues and former pupils.

The standard of excellence achieved in the Bush years was recognised when the School was designated as a Regional College of Art in 1936. Its growing reputation attracted more students and the West of England College of Art, as it was now to be known, needed overflow accommodation in annexes in Clifton and Redland. Since the take-over by

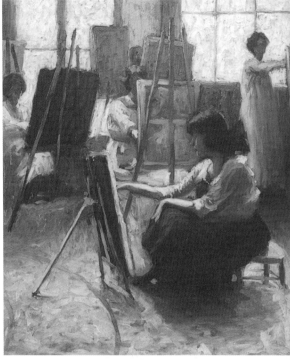

Clifton Arts Club: Beatrice Kerry's oil painting shows members at the RWA in 1914. [Courtesy: CAC].

the city council the curriculum had been set by the Board of Education with students at 16+ for a two-year course leading to the Drawing Examination. Successful students then continued for a further two years to take an advanced examination in one of a number of subjects: painting, illustration, modelling or industrial design.

Donald Milner was now Principal. One of his first moves on being appointed had been to request that the School's annual exhibition be held in the Academy's galleries on the promise that he would 'produce a first rate exhibition'. The request was granted and the exhibition each year was opened ceremoniously with a prominent speaker, setting a pattern which, interrupted only by the war years, lasted until 1969. Milner was elected an Associate of the Academy in 1937 which was the beginning of a long and distinguished service which included five years as President from 1974 to 1979.

The School continued to flourish under Donald Milner, fondly recalled by more than one student as 'a kind and gentle man'. His teaching staff included the much loved, if sometimes formidable, George Sweet as Head of Fine Art for many years and Paul

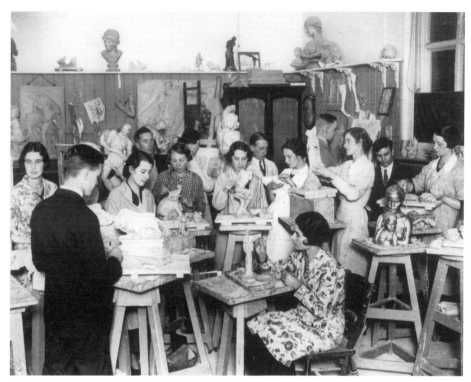

An evening sculpture class at the Municipal School in the early 1930s. [Courtesy: Andrew Wheeler]

Feiler, Sweet's assistant from the late 1940s. In his obituary tribute in 1997, Bernard Dunstan recalled that Sweet was able to bring many leading British painters of the time – William Coldstream, Claude Rogers and William Townsend – to exhibit at the RWA and to talk to his students. George Sweet was also a leading figure in the Academy, serving on the council and hanging committees for many years, and occupying, at one time or another, most positions on the council. Former students look back on the Milner years as another 'golden age', with expert tuition in sculpture from Roy Smith and print-making in the hands of Rachel Roberts (wood engraving) and Kate Rintoul (lithography). Dress design was also taught by Joan Nunn. In 1952, Roy Smith was photographed for the *Evening World*, one of the city's evening newspapers, sculpting a head of Joe Davis, the recently retired world snooker champion. Readers would not have been entirely surprised to learn that the master potter was the first billiards or snooker player to sit for a sculptor. Another sculptor, Robert Clatworthy, a student at the West of England College from 1944-46, returned to teach there in the 1960s. Bernard Dunstan, who would be later President of the Academy, taught fine art in the late 1940s.

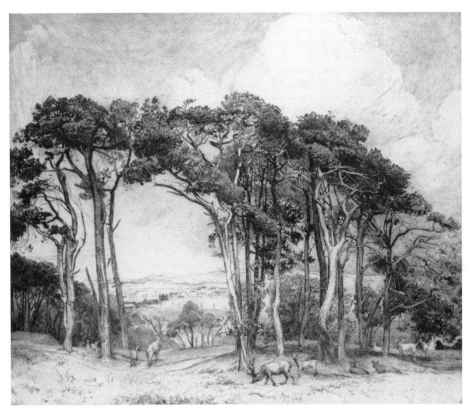

Looking East from Ashton Park, Reginald Bush, etching c.1917.

RWA member Francis Hewlett, who was a student at the West of England College from 1948 to 1952 recalls the teaching methods in those heady days in the Painting Department:

'I was eighteen when I started, and met George Sweet for the first time, in the Life Room at Queen's Road. He was not a very large man physically, but his presence in the room generated a palpable air of concentration and seriousness. He insisted on an intense application to drawing from observation and taught in the traditional way, moving from student to student, correcting their efforts with small drawings of his own on the margin of the student's drawing. The model, clothed or nude, rested every half hour or forty minutes depending on the nature of the pose, and silence was observed while the model was posing. The few remarks he made were terse and to the point.

'Sweet had been appointed by Donald Milner in the late thirties, and exhibited at the

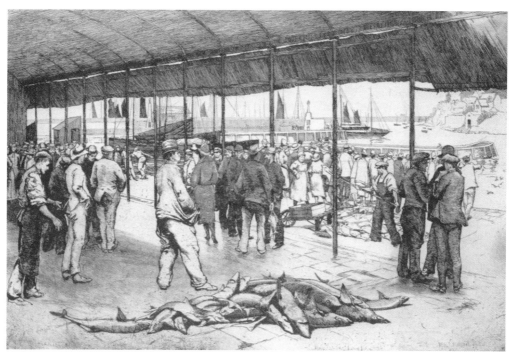

The Fish Market, Brixham, Reginald Bush, etching 1933.

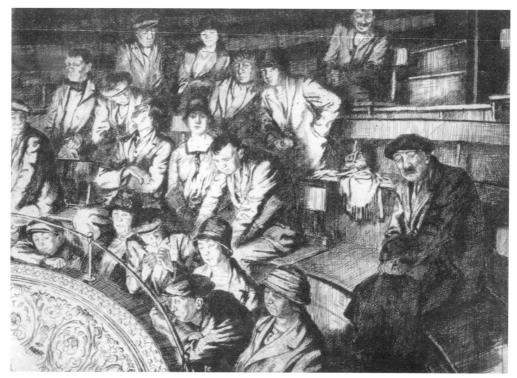

In the Gallery, Alexander J Heaney, etching c.1928.

RWA regularly. After the war he staffed his department himself with like-minded young painters like Hilda Scott and Robert Hurdle. It was a very small department, and the teaching was direct and focussed. Drawing was the main activity, and George's example created an extraordinary band of young enthusiasts who had a real craze for drawing, working very long hours both in the department and out of it. Some names come immediately to mind, David Bates, Royston Clapp, John Pitcher, Quentin Williams, Robert Organ, Thelma Reed, John Jones, Alan Halliday, Maurice Lovell, among many others.

'The atmosphere at the school was striking (although probably not so very different from other colleges and universities in the immediate post-war years). Alongside the seventeen- and eighteen-year olds, who had the energy and ignorance of adolescence, were the returning servicemen and women, older, experienced and with lost time to make up.

'George was cultured and widely read; he spoke French and Spanish fluently. His great and abiding influence was to instil in us the sense that Art was a deeply serious activity with a long and complex history that we had inherited and were now expected to develop. It was indeed heady stuff for a teenager.

'He was much less sure of himself than he appeared. He had been at the Slade at the same time as Claude Rogers and William Coldstream who, with Victor Pasmore, had founded the Euston Road School in 1937, and I think he saw himself as the Bristol branch of 'Head Office', as he jokingly referred to it. In his seventies and eighties he had an extraordinary burst of sustained and brilliant objective painting which is still to achieve proper recognition.

'George's passion for drawing was a good teaching method. It did not suit every student, but for those who found it useful it

The Printer [self portrait], Alexander J Heaney, etching 1919.

Portrait of a Man [self portrait], Nathaniel Sparks, drypoint 1929.

An Etcher [Harry Banks], Dorothy Woollard, drypoint c.1918.

fostered a level of intellectual honesty, and a necessary humility in the experience of looking and seeing, that provided a framework and scaffolding for the student's working future. Its disadvantage was that practically everything else – colour, composition, expression – remained comparatively unexamined. I now think that this apparent void in the teaching was deliberate, and left us the rest of our lives to sort out and fill with our own personal intentions.'

After the Second World War, the Ministry of Education introduced a new two-year Intermediate Examination course followed by a two-year National Diploma of Design Examination course. In 1969 this was in turn superseded by a three-year Diploma in Art and Design (Dip.AD) with university entrance qualifications at 18+ required usually after a one- or two-year Foundation Course had been successfully completed.

In the interim, a proposal to move the College to the former Muller orphanage, by now vacated, foundered for lack of Government approval. The space problem was eventually overcome with a move to purpose-designed buildings at Bower Ashton in the late 1960s. The College was then designated part of the proposed Bristol Polytechnic and in 1992 it became one of the twelve faculties of the new University of the West of England, Bristol. When the College moved to Bower Ashton, the School of Adult Art Studies remained at Queen's Road, to be managed by Filton College, with the city council continuing its lease of that part of the RWA building which had housed the faculty.

In 1999, the Academy entered into a unique educational alliance with UWE when Karen Morgan, as chair of the university's board of governors, announced the establishment of a body to be known as 'The Patrons of the RWA'. Its purpose was to nurture a partnership between the two related charities and to expand their contribution to the cultural and educational life of the west of England. Within three years, a number of projects had been realised as part of this collaboration. In 2000, links were strengthened when the new Dean of the Faculty of Art, Media and Design, Professor Paul Gough (a painter who had been elected to the Academy in 1997) was appointed to the Academy's Council and to the Finance and General Purpose Committee. In that same year, a joint RWA/Faculty research associate took on the task of assembling images, statements and biographies of all artist members in the Academy to add to the Academy's web site. The new site featured work by most of the academicians with links to many of their gallery sites.

The Academy has had a long history of sponsoring student exhibitions, prizes and scholarships, with regular exhibitions of students' fine art work, including large shows of work from the six art colleges in the south-west region. Two bursaries of £1,000 are available to students in final-year undergraduate or first-year postgraduate courses in painting, printmaking, sculpture and architecture. In 2001 the University of the West of England sponsored a prize for the most outstanding drawing in the Academy's Annual Exhibition.

The relationship with UWE continued a long tradition of working with local and regional schools. RWA educational activities include gallery tours and practical demonstrations by exhibiting artists, 'hands-on' workshops and slide lectures by professional artists and art historians, student bursaries and the opportunity to submit work to open exhibitions. A major show of paintings by Bristol school children on the theme of discovery was held in 1997 to mark the Cabot anniversary.

As part of the RWA/UWE alliance, the Faculty of Art, Media and Design and the School of Architectural Planning will enjoy unique access to the Academy's exhibition space. One of a number of projected major shows, an international printmaking exhibition from the USA, will be held in 2004, curated by staff from the Centre for Fine Print Research at UWE. The show will feature some of the most impressive American printmakers in the past two decades, including Jasper Johns and James Rosenquist. There had been an early collaboration when, in 1999, the Academy hosted IMPACT, the first ever international conference on multi-disciplinary printmaking, attracting over 300 delegates from 28 countries. This project was devised by the Faculty of Art, Media and Design and continued the tradition of the Academy's promotion of printmaking as a fine-art medium.

The symbiotic relationship between academy and university strengthens the links. Many RWA academicians are graduates of the former West of England College of Art and its successors, including the sculptor Ann Christopher RA. Current academicians who have taught at Bower Ashton include Neil Murison, George Tute, Stewart Geddes and Alfred Stockham, who became curator of the RWA picture collection in 2001.

Recent President Peter Thursby and current President Derek Balmer were both trained

at the West of England College of Art and both have received honorary degrees from the University, as has Dr David Bethell CBE, a former Chairman of the Committee of Directors of Polytechnics. Dean of the Faculty, Professor Paul Gough, has been a member of the Academy since 1997 and has served on the Council since 2000. In recognition of his work in creating the educational alliance, UWE Vice-Chancellor Alfred Morris was created an honorary academician in 2002. RWA members will enjoy access to the UWE libraries and other learning resources, and University staff and students will gain access to exhibitions and other events in the Academy.

The Life Room in 1998.
[Courtesy: Filton College of Art]

In 2002, the Faculty opened negotiations with Filton College to collaborate on a number of joint ventures so as to continue to enrich the range of art and design educational provision in the city. The College is noted for its adult education – particularly in the fields of stained glass and jewellery – and the Academy's purpose-built studios offer a unique home for art students. With the three organisations – RWA, UWE and Adult Education – working hand-in-hand, the studios, which offer space for master-classes, workshops and demonstrations, could become the centre-piece of the Academy's educational work well into the twenty-first century.

The Hogarth Altarpiece

A curious episode in the Academy's history was its acquisition of the great triptych by William Hogarth commissioned by the church vestry as part of the high altar at St Mary Redcliffe. Hogarth completed the work in 1756, for the sum of £525. 'The Altarpiece', as it is commonly known, is perhaps the most remarkable work of art in Bristol. The left-hand wing of the triptych shows the Sealing of the Tomb in the Garden of Gethsemane, with its counterpart on the right showing the three Marys at the empty tomb on Easter morning. The huge centre-piece, measuring 32 feet high by 24 feet wide, has Christ ascending to the heavens, watched in awe by St Peter and the other disciples. The huge canvases were painted in London, although the supporting frames were designed and made in Bristol under the direction of the ubiquitous eighteenth-century architect and craftsman, Thomas Paty.

By 1755, when he was invited to undertake this massive work, Hogarth was an established portrait painter and creator of the social satires, such as the eight pictures of *A Rake's Progress* and his masterpiece, the *Marriage à la Mode* series in 1743-45, for which he is best known today. The Bristol commission was not, though, a complete departure as Hogarth had, some twenty years earlier, painted such works as *The Pool of Bethesda* and *The Good Samaritan* for St Bartholomew's Hospital, London.

A hundred years later, that kind of Grand Manner painting was going out of favour. At the time, there were proposals to restore the church and, as Michael Smith graphically put it in *St Mary Redcliffe: an architectural history*, Hogarth's Bristol altarpiece must have seemed incongruous to Victorian restorers wedded to the Gothic Revival. 'Raised arms, startled looks, billowing draperies, landscape settings in an Italianate rococo manner are hardly Church of England taste ... The traditions which Hogarth admired were those of Raphael and Poussin, of the Italian baroque; a great tradition which too few English congregations have been educated to enjoy. The failing of the Gothic Revivalists ... was that they could admire no art but the Gothic, and even now there are

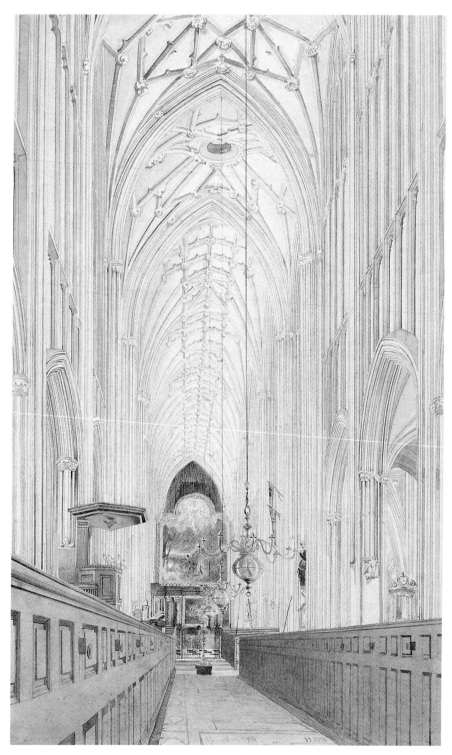

James Johnson's watercolour of the interior of St Mary Redcliffe in 1828 shows the altarpiece in its original setting. [Bristol Museums & Art Gallery}

many who prefer the fake Gothic to the genuine Baroque.'

So, in the 1850s, someone at St Mary Redcliffe seems to have hit on the bright idea of dumping the unwanted masterpiece on the Bristol Academy. Where better to show such a monstrous painting than in one of those newly built, large and airy galleries? The Academy was invited to purchase it, but declined. In an unusual transaction, the Vestry then sold it off for a token £20 to a private individual – in fact, it was Alderman Thomas Proctor, later to donate his house on Clifton Down as the Mayor's (later, Lord Mayor's) Mansion House – on the understanding that he present it to the Academy for safe keeping and display. So the Academy was persuaded to take the triptych into their custody and, dutifully, it was displayed there for some time. It took up so much space, however, that eventually the canvases were taken off their stretchers, rolled up and put into store.

From time to time, its fate was discussed, but as the Academy were custodians only, it could not easily be disposed of. Repair works, estimated at a sizeable £300 in 1909, would be needed. In that year, the Vestry agreed to the Academy's putting it up for sale, with any proceeds being shared in a 3:1 ratio in the Academy's favour, provided no expense fell on St Mary Redcliffe. Nothing came of the proposal to sell, which was severely criticised in the Bristol press. For its part, the church, having got the unwanted altarpiece off its hands, didn't want it back. Finally, at the beginning of the Second World War, in 1939, the City Art Gallery agreed to store it in their basement for safe keeping.

In 1951, the game of musical altarpieces started up again and the City Art Gallery insisted that the RWA take it back. The Academy reluctantly agreed, and the altarpiece's future was again in question. By now, substantial restoration was needed. Lord Methuen, the Academy's president, seems to have worked some magic. He approached the Dulverton Trust, which agreed to fund the essential repairs, and the Vestry of St Mary Redcliffe and the Academy agreed (doubtless thankfully) to relinquish ownership and all rights in the work in favour of Bristol Corporation which in a change of heart was now, in 1955, willing to display the altarpiece in Bristol Art Gallery or 'some other gallery under the control of the Corporation'.

That 'other gallery' eventually proved to be the ecclesiastical museum which was being set up in the gutted but now re-roofed St Nicholas Church by Bristol Bridge. There, the altarpiece formed a magnificent background to the museum display. But even this was a temporary phase, as the museum was later forced to close for lack of funding, and became offices. Happily the altarpiece at least remains on view – leaving it there, among the computer screens and filing cabinets, being the cheapest option – but it is a bizarre outcome of a very unusual peregrination around the city.

Detail: the kneeling disciple. [Photograph courtesy: Stephen Morris]

Patronage

From its very beginnings, the Academy owed much to the efforts of public-spirited citizens and, looking back over a century and a half, it seems inevitable that the Wills family played a major role in its fortunes.

Indeed, the city's cultural landscape would look very different without the generosity of several generations of that eminent Bristol family. In the nineteenth century and early twentieth, they helped found, administer and, of course, finance many of the city's great institutions, from public libraries and the Colston Hall to the City Museum and Art Gallery, the emerging university and the Royal West of England Academy, both in its earlier incarnation as the Bristol Academy of Fine Arts and well into the twentieth century.

It was not only money that the Wills gave from their growing personal fortunes, but their time and expertise as businessmen and administrators. They served as MPs, city councillors, they chaired dozens of committees, helped direct the fortunes of what would become the city's leading building society, chaired dozens of committees, and from 1898 to 1936, three members of the Wills family served as the RWA's President. Continuing the family tradition, the late Sir John Wills served as the Millennium Appeal President.

For such families as the Wills, the Frys, the Sturges and the Robinsons, supporting the arts and learning was a matter of doing their religious and social duty in the city that made them rich, and their Non-conformist backgrounds meant that they personally avoided ostentatious shows of wealth. These admirable people did not spend much of their fortunes on themselves. They were certainly not seeking publicity or business advantage, for many of their gifts were given without publicity, and all they expected as a mark of their generosity was their name on a plaque. They gave as individuals, and unlike modern sponsorship, there were no strings attached, no expectation of publicity, no creating a corporate image and no attempts to influence government decisions with judicious donations.

Like most Victorians of the ruling class, they believed in self-improvement, and for their own employees and for the citizens of Bristol, and especially the working class, they wanted to provide free access to high culture – quite the reverse of the 'dumbing down' which would be such a feature of the cultural debate in the late twentieth century – and their money made that possible at a time when there was no central government funding of the arts, and a very small municipal budget.

The Wills involvement with Bristol's Fine Art Academy began modestly and early, in 1863, when Sir William was made an Amateur Member; when much later he became President the institution was in a rut, and in need of re-organisation. The election of Sir William in 1898 undoubtedly upset many artists and lay members who, he wrote, had been running it like a 'closed corporation'.

Sir William (from 1906, Lord Winterstoke) wanted to be of practical use, and brought his business authority and administrative ability to bear on the academy. His presidency was vigorous, direct and effective: in modern parlance, 'hands-on'. He wanted to know everything about the membership, the finances and the day-to-day running of the academy, realising that its role had to be redefined at a time when public demand for a civic art gallery, something other major provincial cities already had, was becoming insistent.

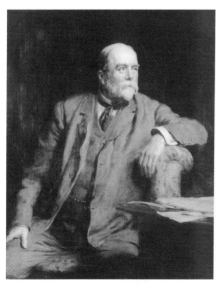

Lord Winterstoke, portrait by Hugh Rivière. [RWA Collection]

The Bristol Academy was then the only building in Bristol suitable for a permanent display of pictures, and although it was holding annual exhibitions which brought in the general public, there was not enough gallery space to display the art collections donated to the Academy, nor indeed the work of the artist members.

There was a proposal dating back to 1886 for the Corporation to take over part of the Academy building itself. Sir William now confided his plans to the editor of the *Western Daily Press*: there was a triangular space at the back of the Academy – today long since covered in villas – on which he would fund the erection of another gallery, to be under the control of the Corporation. This

eminently sensible proposal came to nothing because of the difficulty of building on the site.

Sir William knew that a city art gallery was certain to be established, for in 1899 he had offered the city council £10,000 for the building of just such a gallery next to the existing museum. The Corporation Finance Committee proposed to give a halfpenny in the pound rate towards the cost – an early example of a Public and Private Partnership. Sir William also gave the Corporation a painting – William Müller's *In the Sahara* – which he intended should be the nucleus of a municipal art collection. The *Western Daily Press* comment was favourable. 'It may become a Mecca to those who can afford to indulge their taste for art by making their homes miniature art galleries, and it should also be useful to every class of ratepayer.'

Meanwhile, Sir William's plans for the Academy included the opening of membership to artists of more distinction and a determination not to let the Academy remain a closed working club for artists. 'Black and white' artists like FG Lewin and Samuel Loxton were made members, and Ernest Board and FG Swaish, along with the sculptor Charles Pibworth (best remembered for the sculpture on the Central Library) became associates. He also sought to improve the structure of the Hanging Committee.

Sir William sorted out the relationship with the newly opened City Art Gallery. The permanent collection of paintings willed to the Academy by Mrs Ellen Sharples, along with other works held by the Academy, were transferred to the new gallery on permanent loan, in return for the guarantee that the City Council would spend not less than £500 a year on purchases from the Academy's annual exhibition. As noted elsewhere, this arrangement later caused friction in the 1920s and led to the outright purchase of the loan collection.

Sir William oversaw the 1905 plans to enlarge and redesign the Academy and donated £1,000 towards the project, which he never saw completed, since he died in 1911. A bronze bust of the man who had such a strong impact on the Academy was commissioned from James Havard Thomas and placed in a niche halfway up the marble staircase.

The benefactor's manner may have been resented, but he had changed the professional profile of the Academy and steered the organisation into more modern and democratic

ways. It could be argued – as indeed was suggested by a later President, Donald Milner – that it was thanks to him that the Academy survived into the twentieth century at all and won its Royal status in 1913. A contemporary description of Lord Winterstoke by AB Freeman, author of *Bristol Worthies* published in 1907, called him large in every sense. 'It goes without saying he is a man of very large means and what is much better, also a man of very large heart ... Bristol may well be and is proud of such a fellow citizen and the Corporation conferred the Freedom of the City on him.

'He is a tall, fine-looking man, wearing beard and moustache, pleasant and genial in manner, has travelled much in various countries, is a widower without family and mostly resides at Blagdon Court where, as everywhere else, he is very popular with a large circle of friends. He has taken an interest in shire horses and agriculture in general and often exhibits his stock at local shows.'

Recognising the debt to Lord Winterstoke, it was not surprising that the Academy management committee wanted to keep the Wills connection; they invited George A Wills to become President but he suggested that Lord Winterstoke's niece, his adopted daughter Miss Janet Stancomb Wills, should take over and continue a family tradition of presidency which lasted in all for 38 years. She held office until 1932, during the time when the Academy gained its Royal charter, and her sister Yda Richardson took over until 1936. Several members of the family continued an interested in RWA affairs. It was Dame Janet who commissioned the fine President's chain of office; she gave a sum of money to be invested in an Academy Endowment Fund, and had given generously to the rebuilding programme. In 1915 the Academy commissioned a collection of sketches by 86 members, stored in a splendid mahogany cabinet, which was presented to her in July of that year. It is now in the RWA's collection.

Mrs Yda Richardson at Abbot's Leigh, 1927.

The Wills family's financial support for the 1913 improvements went well beyond the initial £1,000 Lord Winterstoke had donated in 1905. The Appeal prospectus published in July 1913 showed that various members had contributed no less than £8,600 of the

£11,400 then raised towards the projected costs of £18,000. Almost inevitably, there was still a shortfall and in June 1914, Miss Stancomb Wills, as President, announced that she would settle all the outstanding debts.

A study of the Appeal prospectus reveals how parlous was the state of the Academy's affairs at that point, and the ambitious improvement scheme seems, at this distance, something of a desperate last throw. The number of subscribers had fallen off and considerable sums had been spent restoring the fabric of the building. 'The Academy Building in its former state also conveyed the impression of a decadent institution, and this also doubtless operated against its success. For some years there has been a heavy annual loss, whilst the whole of the invested funds have disappeared, and the Academy is at the present moment in debt to the amount of nearly £2,000

The President's chain of office commissioned by Dame Janet.

…If this Improvement Scheme had not been carried through, it would have been necessary to close the Academy entirely in the course of two or three years, a proceeding which would be greatly to be deplored in the interest of Art and for the sake of the prestige of the City.'

That such a drastic course of action was avoided was very largely due to the generosity of the Wills family.

Wills patronage extended well beyond the Academy. From the earliest days of the W D and H O Wills tobacco empire, the education and enlightenment of the workers was an aim. The very first works outing was by train to the Great Exhibition of 1851, and the employees were provided with a library and encouraged to attend evening classes.

[At this point an explanation of the Wills family tree is needed. Henry Overton Wills the first, the founder of the firm, was the father of W D and of H O the second, whose sons and grandsons became the main patrons of the city. Sir William Henry Wills, son of W D, and later Lord Winterstoke, was the chief benefactor; H O the third was another, as were his sons, George, later Sir George, and Harry.]

The Wills family were not Establishment figures; they were not pillars of the Anglican church or Conservatives or Merchant Venturers, nor were they landowners. They were industrialists, Congregationalists and Liberals who believed in living plainly and doing

good to the less fortunate, as well as serving their city as councillors and MPs. Lord Winterstoke, for example, was a Justice of the Peace, a Member of Parliament and Sheriff. 'With the possible exception of Lord Winterstoke, flamboyance and ostentation was not to their taste. Sobriety and distaste for personal extravagance, which sometimes appeared as petty meanness, are their most personal characteristics,' says Bernard Alford, their biographer. S J Watson, in a study of the Wills family, tells how Sir William Wills himself, when visiting London for Great Western Railway board meetings at Paddington, used to pawn his travelling overcoat on arrival and redeem it for his return journey – which he reckoned cost him less than the tip that a cloakroom attendant would have expected from him.

Nor was their philanthropy sectarian. Despite being Congregationalists, they subscribed to the completion of Bristol Cathedral and the restoration of St. Mary Redcliffe; they gave generously to the YMCA, they supported the Boys Brigade and the Shaftesbury Crusade, as well as running their own Sunday School and Mutual Improvement Society at their Bristol Tabernacle.

They were also involved in the Bristol Athenaeum and the Bristol Institution, as well as the Museum and Library Society, and without Wills wealth, Bristol University would have remained a University College for much longer than it did. They left their stamp architecturally, not just with their massive red-brick factories and bonded warehouses, but with university buildings, the City Art Gallery, libraries, to say nothing of their own Victorian homes across the Suspension Bridge.

The list of the family's benefactions is almost endless: Havard Thomas's statue of Edmund Burke on the Centre was paid for by Lord Winterstoke, and when the Reformatory at Red Lodge closed down in 1919 and the building became an adjunct of the City Art Gallery, Sir George Wills helped meet the cost of the conversion. Sir Edward funded building works at the Cathedral, the Wills family paid for the convalescent home built to mark Queen Victoria's Diamond Jubilee, they subscribed to the extension of Clifton College; George Wills was associated with the Winkworth Industrial Buildings for the poor in Jacob's Wells, and in 1920 came the building of St Monica's Home of Rest on the Downs.

The Wills' impact on the arts, education and religious scene in Bristol had begun fairly early in Victoria's long reign and was to peak around the end of the century as their wealth and influence grew. After the formation of Imperial Tobacco in 1901, the personal fortunes of the four leading members of the family were well over one million pounds each and they were reckoned to be the richest family in the country. Lord Winterstoke, as chairman, had a personal fortune of more than £2.5 million. Until then, the family fortunes had been founded not on large inheritances but on profits. In 1876 the W D and H O profit was £21,000, by 1901 it was £750,000.

The first Wills cultural gift to the city was the purchase of shares in the company which built the original Colston Hall, opened in 1867. There were four medallions in the spandrels of the arches in the Great Hall inside, naming the four citizen shareholders, one of whom was W H Wills, who also gave £3,000 to buy the organ. A marble relief portrait, rescued from the fires of 1898 and 1945, still stands at the top of the stairs, describing him as 'director'. After the 1898 fire he paid £5,000 for the new organ to be installed in the rebuilt hall. He also gave £1,000 for the organ at Bristol Grammar School, for the Wills were a family of organists, perhaps because of their religious background, and later had organs installed in their own country homes.

The Wills involvement in the city's public libraries had started with their support for the Literary and Philosophical Institution and the Library Society, whose collections of books were moved to the new Museum in Queen's Road when it opened in 1872 in its purpose-built Venetian Gothic building by Foster and Ponton. Shortly after this, the Public Libraries Act of 1874 made the Corporation responsible for library provision. Branch libraries were needed, and since the Library Committee was allowed no more than a penny rate, private enterprise had to step in. Sir William Wills, who was MP for Bristol East, gave his constituents in St. George their branch library in 1898. Sir George followed suit with the gift of the Bedminster library in 1914. The architect of both buildings was, naturally, cousin Frank.

Sir William's interest in the City Art Gallery began in 1899 when he provided £10,000 to buy the hall used by Bristol Rifle Volunteers next door to the Museum. He was dissatisfied with the design for the art gallery, took over the scheme and appointed Sir Frank Wills as architect. In 1901 he increased his contribution to £40,000 and virtually

paid for the entire project.

Frank had trained with the noted Bristol firm of architects, Foster and Wood, and was responsible not only for the Wills factories in Bedminster and Ashton Gate but a wide variety of other Bristol buildings which still stand. He could work in several styles, designing almshouses, chapels, churches, schools and country houses. Sir Frank was a large, Falstaffian figure, and an eccentric; if his hat was set on the bust of his enobled cousin Lord Winterstoke, it indicated that he was in his office.

At the opening of the City Art Gallery in 1905, when Sir William was hailed by the Bristol press as 'a local Mr Carnegie', the chairman of the Museum and Art Gallery Committee wrote: 'A sense of relief and satisfaction was felt now that Bristol was the happy possessor of a temple of art worthy of her position among the cities of the United Kingdom'. The building, an important example of 'Edwardian Baroque', was later described by historian Bryan Little as the architecture of Pomp and Circumstance. Over the four months from opening, 289,000 people visited the first loan exhibition. In 1925 Sir George Wills offered to pay for the extension at the rear of the building, and again Frank was the architect.

Another great Bristol cultural institution, the University, owes everything to the Wills family, who in their far-sighted generosity gave one of the city's most famous landmarks, the University Tower at the top of Park Street, opened by King George V in 1925. For once, the architect was not Frank, but the noted Sir George Oatley.

The association of the family with University College had begun in 1877 when Henry Herbert, known as Harry, attended classes, and eventually trained as an engineer. The first University College buildings were paid for by the Fry and Wills families who between them gave £35,000 to the project in the 1880s. It is mainly thanks to Wills bounty that the University College won its charter in 1909; although all Bristol responded to the campaign, 79 per cent of the money needed came from the Wills, and in dramatic fashion. On January 14, 1908, the University College Colston Society met for its ninth annual dinner, and George Wills was President that year. A M Tyndall, who was Professor of Physics, described the scene:

After the port was circulated, George rose to make what was probably the most

exciting speech in Bristol university history. He took a letter from his pocket and read its contents. The letter was from his father, HO the third, who was 80 at the time …'I have decided,' it said, 'to promise £100,000 towards the endowment of a University of Bristol and the West of England, provided charter be granted within two years from this day.' There was a gasp in the audience and prolonged cheering. The atmosphere on the announcement of this gift of what seemed a complete fortune was electric. We all stood up, waved our napkins and proceeded recklessly to order Champagne at 7s. 6d a bottle.

HO Wills was made the first University Chancellor, and it was in his memory that his sons built the Memorial Building, saying 'We want something that will be there in 400 years' time'. George and Harry had no particular intellectual interests, but believed in people who did.

Several members of the family gave time and money generously. Harry and brother Melville endowed the Physics Building on Royal Fort, after George, who was also Treasurer of the University from 1909 to 1918, had bought the Royal Fort and its gardens, and in 1920 the Victoria Rooms for the student union; Frederick Wills served on the College council. Other gifts from the brothers were Canynge Hall and Mortimer House, and the sites of the Stoke Bishop halls of residence, as well as the athletic ground at Coombe Dingle. No wonder Bristol was envied by other universities less well endowed, for it is estimated that the Wills family gave the University, over fifty years, about £1.25 million, a staggering sum if translated into twenty-first-century values.

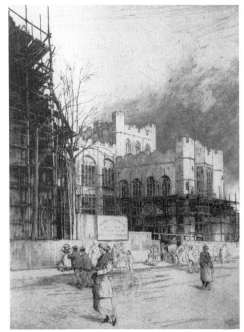

Building the University of Bristol, Reginald Bush, etching, 1922. [Bristol Museums & Art Gallery]

With the birth of Beveridge's Welfare State and the Arts Council, patronage changed its nature, and huge personal gifts of money became much more rare. Patronage was replaced by sponsorship, and indeed Imperial Tobacco became the generous sponsors of concerts in the Colston Hall and seasons at the Theatre Royal. They commissioned work by contemporary artists for their new

premises at Hartcliffe.

The Wills family still allied themselves with social and artistic good causes in the city, but the nature of arts funding had changed: organisations actively seeking sponsorship money had to tailor their programmes to suit a company's tastes and provide for corporate entertainment and free tickets: all far removed from the old relaxed attitude.

The relationship between industry and the arts had become much more tricky. In 1934 JB Priestley could write, without any fear of controversy, that 'the smoke from a million Gold Flakes solidifies into a new Gothic Tower for the University'; when, a few decades later, Imperial Tobacco announced their sponsorship of a season at the Bristol Old Vic, the late actor Paul Eddington, who was a fervent anti-smoker, resigned from the Board of Governors. If earlier recipients of Wills' donations had been that fastidious, Bristol would not now be claiming to be a city of culture. That it is, is largely thanks to one remarkable family.

An Art Gallery for Bristol

The announcement at the end of 1899 that the Academy's President was to donate £10,000 to Bristol Corporation to secure a site for a proposed municipal art gallery was not received by his colleagues in the Academy with unalloyed delight. Only a few years earlier, Academy members had been among those pressing for just such an addition to the cultural map of the city, criticising the corporation for not following the example of other large cities. The lay members saw such provision as helping create an art-loving Bristol public, while the artist members saw the prospect of a further outlet for their own work.

Sir William had himself started the ball rolling by donating a picture to help establish a corporate collection. This prompted the Academy Committee in June 1898 to call for the Corporation 'to become the purchaser of pictures at the Bristol Academy Exhibition with a view to the formation of a Municipal Gallery'. The Academy would, they continued, at once become important to artists 'of every country and works of great value would find their way here.' The Dean of Bristol Cathedral added his weight at that year's annual meeting, saying the 'the City, as the Metropolis of the West, is prominent and holds its own in most matters, but she is not equal to other cities in the support of Art.'

But when the news of Wills's gift to the city made the establishment of a municipal gallery a certainty, doubts began to creep in. A delicately worded statement from the Academy Committee placed on record 'the high appreciation of the great generosity of the President' but added that it trusted that 'in the establishment of the Municipal Gallery provision will be made that the Corporation may supplement and aid and not, as some have apprehended, interfere with the work of the Bristol Academy'. It cited Birmingham as a model, where the Corporation Gallery existed side by side with the Society of Artists, 'an institution holding exhibitions of current Art similar in all respects to those of the Bristol Academy'. The objects of the Municipal Gallery should be similar to those

of the National Gallery and Tate Gallery, 'while the exhibitions of the Bristol Academy should be for Bristol and the Western Counties what those of the Royal Academy are for London and the whole of England'.

Fears that a municipal gallery might impinge on the role of the Bristol Academy were not unfounded. A report of the Joint Libraries and Museum Committee in June, 1900 argued that the Art Gallery should have powers to give lectures and classes and receive fees for instruction, to let galleries at fees for exhibitions and to manage the School of Arts and the Fine Arts Academy. Such powers would be included in a Parliamentary Bill.

All this was explosive stuff. Sir William moved to quell fears and at the next Academy Committee meeting was at pains to say that some of the objects proposed were quite new to him, 'in particular the proposal that the Academy and School of Art should be taken over and managed by the Corporation'. He reiterated his support for the Academy view that the work and objects of the Corporation Gallery should be quite separate and distinct, and that he had never intended to provide a Gallery to be used for exhibitions which would at all interfere with those carried on by the Academy. He would make it a condition of his support that the Corporation Gallery should not be used for selling exhibitions, adding perhaps significantly, 'so long as the Academy had a separate independent existence'. He thought that, until the Corporation could build up its own collection, the Academy might lend its own pictures for display in the municipal gallery.

This was a sensible suggestion, as the Academy already had the problem of how to use its galleries for two distinct purposes: to display the Permanent Collection and to hold exhibitions of new work. Historical works remained inaccessible for long periods during the spring and autumn exhibitions, and American visitors in particular were disappointed that they could not see paintings and pastels by the Sharples family. Meetings took place between Academy and city council to discuss respective roles and how the Permanent Collection could be used to best advantage. For the city, Alderman Jose was uncompromising in his view that the city should take over the academy and its collection and have done with it.

Negotiations dragged on for two years, before a compromise suiting the Academy was reached. In essence, the two bodies would complement each other and the Academy

would retain its own identity and continue to hold its annual exhibition of work for sale, without competition from the new gallery. This was all eminently sensible, not least for the citizens of Bristol, who would now have two significant providers of fine art. The parallel with Birmingham was reiterated in the Academy's report for 1904.

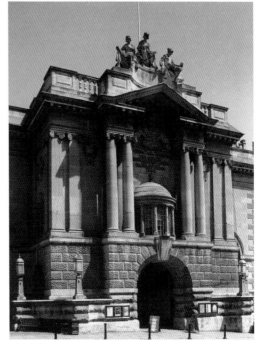

'A noble casket': the Wills gift to the citizens of Bristol. [Photo: John Trelawny-Ross]

The Bristol Municipal Gallery finally opened on February 20, 1905, when most of the paintings on display were loaned by local collectors. The Art Gallery then had only twelve paintings that it could call its own, and would have to rely on loans (including that from the Fine Art Academy) for some years, with the Corporation beginning to acquire paintings through purchase, gift and bequest. At the opening ceremony, Alderman W R Barker, in baroque terms to match the flamboyant architecture of the building, paid tribute to benefactor Sir William Henry Wills: 'He has provided a noble casket, and only asks that both now and hereafter we shall provide corresponding jewels, in the shape of art collections worthy of the building and of the city'. That first exhibition ran for four months and was attended by more than a quarter of a million people, and in its first four years, gallery staff recorded an astonishing 1,718,450 visits. This might have been no more than curiosity or civic pride, or perhaps Bristolians were interested in art after all, provided it was offered free of charge. Whatever their motivation, Alderman Barker was in no doubt that it was good for them: 'it is impossible to estimate the amount of pleasure of the purest kind that has thus been shared by all classes of the community.'

By 1910, it was agreed that a loan of the Academy's collection should be 'permanent', so long as the Bristol Art Gallery spent not less than £500 a year in the purchase of pictures at the Academy's spring exhibitions. Alderman Barker, chairman of the Art Gallery committee, in confirming this arrangement, added the caveat that his committee assumed that there would be suitable pictures from which to select. The *Times and*

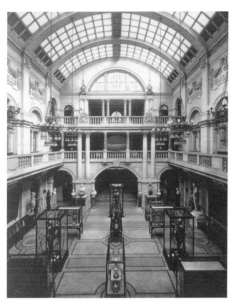
The interior, 1905. [Bristol Museums & Art Gallery]

Mirror commented at the time that this commitment to buy should have a salutary effect on the quality of pictures submitted to the annual exhibitions by artists from other parts of the country. Poor sales in recent years had led to a deterioration in the quality of the annual displays. As to the criticism that artistically some of the pictures in the Academy's permanent collection were not worthy of being hung in the Municipal Gallery, the writer thought their historical value justified their presence. All the work could now be seen to much better advantage. Until then, the pictures had been scattered all over the Academy building and many had been in a neglected condition.

In that same year, the Art Gallery purchased from the Academy a number of items, including a marble group, *The Rape of the Sabines*, several busts, including those of William Macready, William James Müller and Queen Victoria and Prince Albert, *Boadicea* by local sculptor CJ Pibworth and, the *pièce de resistance*, the great chimney-piece from Lewin's Mead which now dominates the far wall in the Museum café. The chimney-piece apparently changed hands for £100 as it was immediately insured for this amount.

Before the establishment of the city's museum and, later, art gallery, the Bristol Academy of Fine Arts was a natural candidate for benefactions. It had acquired four magnificent Assyrian reliefs dating from 860BC. These had originally been excavated in the 1840s at the ancient city of Nimrud (the Biblical Calah) in Iraq by the important Assyrian scholar, Henry Layard, who sent a number of reliefs back to London and institutions in other major cities. He left much behind, and it was the British Consul-General in Baghdad, Henry Rawlinson, who sent the four reliefs to the Bristol Academy. Rawlinson had once lived in the city with his aunt and had attended Pocock's School. Presumably this was why Bristol was chosen for the gift. One of the Bristol reliefs found its way to the British Museum in London, and after much haggling the other three were sold to the City Museum for £400 in 1905; they had lain unseen and uncared for in the Academy's basement for half a century and the growing museum was thought to be a

better home for these treasures. They are now a highlight of the city's collection.

The 1910 purchase agreement was not honoured to the Academy's satisfaction. The City Art Gallery did not religiously spend £500 a year at its exhibitions and in February 1931, after complaints from artist members in particular, the chairman of what was by now the Royal West of England Academy, wrote to the chairman of the Museum and Art Gallery Committee pointing out that there was an accumulated deficit of just over £1,500. The Academy proposed that the city should spend the deficit and pay the sum of £10,000 in return for the transfer to the city of 'the whole of the portraits and pictures in question', including the Sharples portraits. In submitting the formal proposal to Alderman J Fuller Eberle, chairman of the Museum and Art Gallery Committee, Frank Cowlin for the Academy commented that 'in the last few weeks the [Academy] Council had been approached by a reliable firm of art dealers, who affirm that [the Sharples portraits] can easily be sold for a sum between twenty and thirty thousand pounds, and probably more ... and it is probably safe to say that the total value [including other work in the collection] is not far short of fifty thousand pounds.' The Chairman of the RWA Council concluded by saying that he felt very strongly that the importance of the Royal West of England Academy had never been sufficiently recognised, and that he would welcome a much closer liaison between the two bodies.

It seems from subsequent records that the dealers' astonishing valuation must have been based to a degree on wrong attributions of some of the paintings which changed hands. A portrait by Sir Anthony Van Dyck was a copy, and not by him personally, and a Richard Wilson self-portrait turned out to be more accurately described as 'Portrait of an Artist, Continental School'.

The highlights of the pictures which then passed into the public collection were a major work by the seventeenth-century Flemish painter Jacob Jordaens and the Sharples'

In 1905, paintings were still double- and triple-hung as a matter of course. [Bristol Museums & Art Gallery]

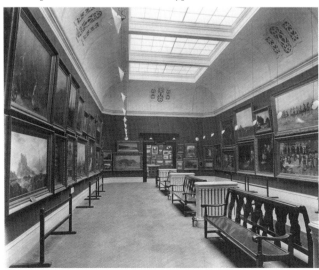

The Nativity,
Jacob Jordaens,
oil, 1663.
[Bristol Museums & Art
Gallery]

family collection, including James Sharples' portrait of General Washington and notable
Bristol set-pieces by Rolinda including the trial of Colonel Brereton, the Races at
Durdham Down and an interior of the Clifton Assembly Rooms.

Edwardian Pomp

By the turn of the century, the artists appeared to have little influence on Academy policies. The Management Committee had grown to eighteen, of whom only five were artists, and an autocratic President had taken powers to personally nominate painters and sculptors for membership. Sir William was accused of having altogether too much power, his response to which was to repeat his former criticism of a 'closed shop' mentality among some of the artists. There is no doubt that the President was acting in the Academy's best interests in seeking to raise the status of artist membership, and the enrolment of a highly respected artist like Sir Alfred East as an exhibiting Vice-President was a shrewd move in those deferential days.

The 10-mile residential qualification had long since been abandoned and mixed exhibitions were now a welcome feature. The spring exhibition in 1905 brought, on loan, work by George Morland, Gustave Doré, John Millais, Jean François Millet and several canvases by G F Watts. These were big names, and there were big artist figure-head names on the roll-call of the Academy, too, when Sir Alfred East, Sir Edward Poynter and Sir Hubert von Herkomer could, at least in spirit, sit alongside fellow vice-presidents Sir Gilbert Wills, Francis Fox, Francis Fry and J Fuller Eberle. But as the Edwardian years unfolded the body of artist members continued to have little say in the affairs of their academy. Nor did it seem that they were especially anxious to become involved. One speaker at the Annual General Meeting in 1913 could comment tartly that of twenty speakers from the floor to precede him not one had been an artist.

Council Chairman Ernest Savory's main thrust of criticism was to reiterate the old complaint about Bristol's indifference to art compared to that shown in the great cities in the north of England, but he ingenuously attributed the three years' accumulated losses of £1,300 (sales had totalled £2,472 in the period) to another factor: the rise of the motor car, which he thought had diverted public interest from fine art. To encourage visitors, concerts were held each Wednesday but 'the Council would like to see the

exhibitions exercising a wider influence, and would welcome a much larger attendance on the part of the Industrial Classes.'

The Clifton Arts Club, which would hold many exhibitions at Queen's Road, was founded by Miss Alice M Williams ARWA in 1906. Its secretary was Miss Amy E Krauss RWA whose paintings were described in the local press as 'Post-Impressionist work in its milder form'. For some time, the Club might be said to be more in tune with contemporary French art than the Academy. The fashionable French portrait painter, Jacques-Emile Blanche, was President for a while, and the Club counted academicians Miss Octavia Cox and Romilly Fedden (an uncle of Mary Fedden, who would become the Academy's President in 1984) among its members, along with architect Henry Dare Bryan.

Despite all the traumas and controversies which had dogged the Academy since its foundation, one aspect of its work which had been unfailingly successful was the Life Class for Artist Members, Associates and approved students. Now, the election of more women painters led to their demanding access to nude life drawing sessions. Mixed classes being too advanced for Bristol taste, arrangements had to be made for the ladies to have their own life drawing classes. This was an attitude reflected in the outraged response in some quarters to the showing of James Havard Thomas's *Lycidas*, a full-sized figure sculpture, in 1906. A 'panel of ladies', possibly well chosen, was consulted and raised no objection, but the sculpture was nevertheless re-sited to a less prominent position. It is now in the Tate Britain collection on London's Millbank. There was an irony in this reaction to a nude sculpture as E H Baily's *Eve at the Fountain*, which had similarly suffered from a 'certain fastidiousness of taste' when shown at the Bristol Institution in 1823, was one of the major items on display when the City Art Gallery had opened eighteen months earlier in 1905.

Putting aside the opening of the City Art Gallery (for which Sir William Wills was elevated to the peerage), the most significant developments for the Academy in the years leading up to the First World War were the granting of royal status and a major revamp of the building. Piecemeal modifications had been made over the years to meet expansion and changing needs. The School of Art had extended its premises backwards into the pit and, more tentatively, the Academy on the first floor inched out over these

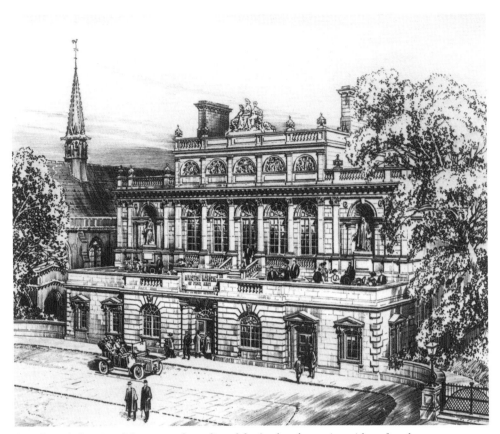

Dare Bryan's drawing of the proposed restyling of the Academy's exterior, with roof garden.

additions to the School. The resultant elevations were ugly but they were largely screened from sight. This extra accommodation was adequate but hardly vibrant and, while Hirst's roadside loggia was attractively three-dimensional, it faced west into the prevailing winds and rain, and the double-flight staircase made a terrace for drinks and refreshment impossible. Major alterations were now needed to take account of changing circumstances.

In 1905 proposals were drawn up for the 'Restoration, Modernizing and Enlargement of the Bristol Fine Arts Academy'. Beautifully drawn sepia engravings by Henry Dare Bryan, published by E W Savory, the chairman of the committee set up to promote the project, were put on show. But it was something of a failure in vision that the proposals were more cosmetic than functional, tinkering on a sumptuous scale rather than a radical rethink. They were, however, very much of their period, Edwardian pomp after

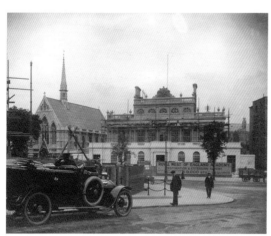

The building work nearing completion shows the modifications made by SS Reay to the Dare Bryan scheme.

Demolition of JH Hirst's grand external staircase.

Victorian eclectic striving, making the Academy more private, more of a gentlemen's club for aesthetes. In addition they were to give Bristol an interior of almost oppressively affluent richness topped by the breathtaking directness of the Walter Crane lunettes.

Henry Dare Bryan, together with the young George Oatley, later to become architect of the University, drew up a plan for a new, two-storey, domed entrance hall in 1908, which was accepted in January 1909. At that time such a scheme of decoration in the French Beaux Arts tradition was still perfectly acceptable. The ground floor had sturdy marble Doric columns and a double-flight staircase with curvaceous wrought-iron balustrades. On the first floor the ceiling panels were compartmented in seventeenth-century style, the marble walls had further panels with swags above and swagged Ionic pilasters were to support the shallow dome. However, Dare Bryan died in 1909 and SS Reay of the firm of Silcock & Reay was appointed to complete the interior. His scheme retained the double-flight staircase, but the Doric columns were changed to blockish square-section pylons and black marble balusters replaced the wrought-iron balustrades. Chunky torchères with rams' heads on the half landing continue the masculine neo-Classical theme. On the first floor similar Doric pilasters support the pendentives of the dome which is Greek Revival in style with key fret, guilloche and anthemenion decoration. Reay must have thought that the severity of his design would relate more harmoniously to Underwood's retained galleries.

The Dare Bryan-Reay scheme seems to have been calculated to overwhelm visitors in the entrance hall and then raise their spirits as they climbed the stairs. Marble is an acquired taste. Byzantium and Renaissance Italy had that feeling for the colour and veining of the natural rock which today is chiefly confined to our enjoyment of semi-precious stones in jewellery. Robert Browning captured the relish of it in 'The Bishop Orders his Tomb in St Praxed's Church' when the dying bishop yearns for

> Peach-blossom marble all, the rare, the ripe
>
> As fresh wine of a mighty pulse........
>
> Some lump, ah God, of lapis lazuli
>
> Blue as a vein o'er the Madonna's breast.

With these lines in mind the attraction of the Amialto marble cladding of the walls, light green fields of veining against black, can be appreciated in the spirit of the Arts and Crafts world. A first impression may be one of antique richness, but there is, in fact, little carved or wrought work. The architects were proposing to rely on the colour of the marbles not the craftsmanship. 'Black 'twas ever antique-black I meant' was the bishop's agonised plea, and the staircase is lined with just that same gloomily rich 'antique-black'.

Then, at the top of the stairs, the light pours in from the windows of Hirst's transformed loggia, but the Walter Crane murals – Painting, Craftsmanship, Sculpture and Architecture – respond to the Amialto and just manage to hold their own against the aggressive colour and patterning of the marble.

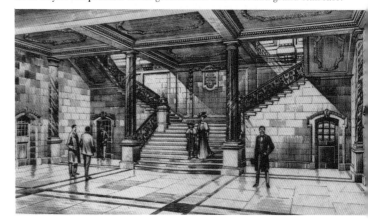

Dare Bryan's impression of the ground floor entrance and grand staircase.

A letter of January 16, 1911 from Reay to Ernest Savory suggests that the original decorative scheme was intended to be more colourful with, on the ground floor, 'Rouge marble' for the skirting, 'red Verona' for the dado and 'Capping in blue Pentelikon'. On the first floor there were to be 'Piastraccia panels, [with] Campan Vert and Pentelikon bands'. Reay concluded that 'in no other way can such a

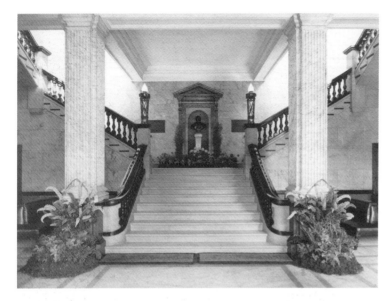

The entrance as completed: modified, but still giving the impression of an Edwardian gentlemen's club.

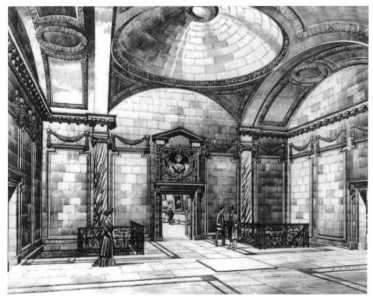

Dare Bryan's proposal for an impressive Beaux-Arts first-floor Reception Hall.

richness of effect and so much dignity be given to a building as by the use of marble in the interior'. This more polychromatic effect would have worked well with the intended murals, a subject upon which Reay was much exercised. He had 'spent the greatest care in dealing with the decorative paintings which it is proposed should occupy the four lunette arches under the dome of the Staircase Hall, and I have accordingly approached three eminent Artists who may be considered as perhaps the best authorities obtainable upon decorative painting as applied to the adornment of classical buildings.'

Reay had obviously chosen his artist for the paintings as he then introduced Mr Preston, 'the most brilliant student at the Royal College of Art, South Kensington', whose 'peculiar talents and classical taste particularly qualify him for such an important work'. Reay had enlisted the support of the eminent Professor of Architecture, Arthur Beresford Pite, whose letter of recommendation was enclosed with Reay's communication. Preston had prepared an estimate for the work of £500 which Reay thought too little; he suggested £800 for the four panels. That left the subjects for the panels which Reay had also determined:

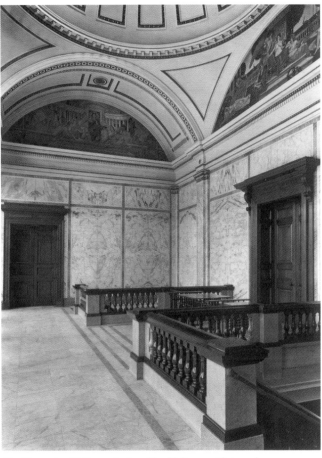

The Reception Hall as redesigned by SS Reay, with two of the Crane lunettes.

> I would suggest that over the entrance to the principal gallery should be, The City of Bristol receiving and encouraging the Fine and Applied Arts, and amongst the others, one subject should indicate the Commerce of the Port of Bristol and its effects upon the Arts and Sciences, another might display the Virtues, and Cabot's connection with the City ought certainly to form another subject.

No more is heard of Mr Preston and the immediate commissioning of the murals was delayed by a series of unfortunate events. Edward VII died in 1910, the President of the Academy, the tobacco multi-millionnaire Lord Winterstoke, whose family would supply the lion's share of the funding for the improvements, died in 1911 and then, a year after the restored building was officially opened on September 29, 1913, the 1914-18 Great War began, and that effectively killed off the aesthetic aspirations of Victorian-Edwardian Britain. The entrance hall together with Walter Crane's oil on canvas murals

Walter Crane: portrait by Sir George F Watts, 1891. [Courtesy: the National Portrait Gallery, London]

were, as a result, made unfashionable almost as soon as they were opened to public view. This lack of recognition is unfortunate for Crane's murals are compositions of a purity in colour and form which can, not unreasonably, be compared with Raphael's murals in the Stanze of the Vatican.

Crane had won a competition for the commission in 1913. The *Bristol Times and Mirror* for April 28 reported that there had been twenty-eight entrants for the £500 prize, judged by professors at the Royal College of Art, South Kensington. These were Beresford Pite, Gerald Moira (Professor of Painting) and W R Lethaby (Professor of Design). Of those exhibiting Crane was undoubtedly the most famous and accomplished artist. He was a notable book illustrator, interior decorator and designer of wall-papers and tapestries. He had executed a number of splendid interiors including a mosaic frieze for the 'Arab Hall' at Lord Leighton's house in Holland Park, along with friezes and panels for other private houses in Kensington and elsewhere. Interior design had a special appeal for Crane, whose grandson, Anthony, would write that 'nowhere else did he find so rewarding an opportunity to combine art with craft, a concept of great importance to him.' Crane was a Socialist and admirer of William Morris, and played a leading role in the formation and activities of the Art Workers Guild and the Arts and Crafts Exhibition Society. His idealistic aim was to 'turn artists into craftsmen and craftsmen into artists.'

Crane's rivals for the Bristol commission included local artists from Bristol and Glamorgan; Eric Kennington, 'now engaged on the C P Railway building for the Ghent exhibition', was the only significant artist other than Crane to exhibit. Crane's winning designs were described by the newspaper as 'full of life and colour, and magnificent examples of this master's work'. It was to be the 68-year old Crane's last major work, and he died in 1915.

Only 'Painting' and 'Craftsmanship' were in place when George V opened the refurbished and now 'Royal' Academy on October 7, 1913. Looking up at them in their lunettes it is as if the Impressionists had never painted a stroke. Crane, only two years

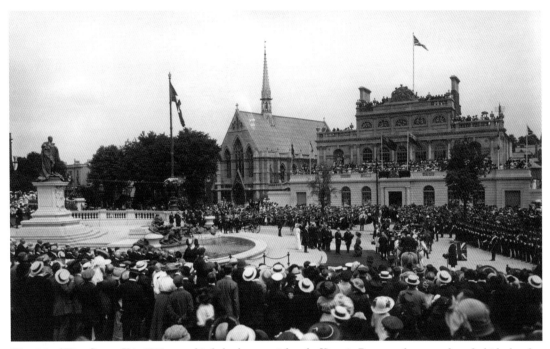

The visit of King George V in 1913 to see his father's memorial at the Victoria Rooms and to open the refurbished and renamed Royal West of England Academy.

before his death, was still working like a contemporary of Lord Leighton, and striving after the effects of Leighton. From left to right the composition of the Painting lunette is static and didactic: a youth draws back a coverlet to reveal new Beauty; Painting, the maiden, has winged Imagination on her one side, aged Tradition at her feet, the mirror of Nature on the other side and on the right naked Truth is being painted by a muscular young artist. Peacocks, orange trees and classical temples make up the background. There is a sensuality of the flesh, but it is restrained by a superficial propriety of instruction. The other three lunettes follow the same format. In Craftsmanship, Adam delves and Eve spins in the centre; smiths, potters, weavers and embroiderers work away in Grecian garments while the prow of a ship in the background hints at a Bristol connection. The last two – Sculpture and Architecture – are more sombre in colouring, as if Crane was oppressed by the thought of his own physical decay. There are mourning groups on each side of the central spirit of Sculpture, who seems herself to be sorrowing. Only in the last, Architecture, is the posed group of figures animated by workmen climbing up a ladder into the picture and scaffolding poles intruding into the exedra of Doric columns which is under construction.

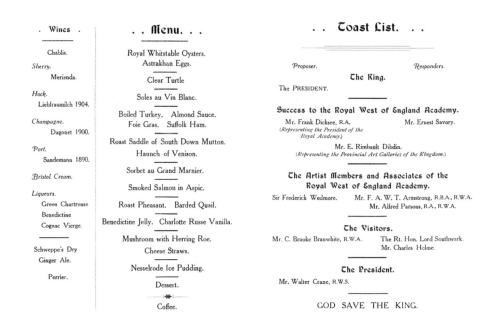

. Wines .

Chablis.

Sherry.
Merienda.

Hock.
Liebfraumilch 1904.

Champagne.
Dagonet 1900.

Port.
Sandemann 1890.

Bristol Cream.

Liqueurs.
Green Chartreuse
Benedictine
Cognac Vierge.

Schweppe's Dry
Ginger Ale.

Perrier.

. . Menu. . .

Royal Whitstable Oysters.
Astrakhan Eggs.

Clear Turtle

Soles au Vin Blanc.

Boiled Turkey. Almond Sauce.
Foie Gras. Suffolk Ham.

Roast Saddle of South Down Mutton.
Haunch of Venison.

Sorbet au Grand Marnier.

Smoked Salmon in Aspic.

Roast Pheasant. Barded Quail.

Benedictine Jelly. Charlotte Russe Vanilla.

Mushroom with Herring Roe.
Cheese Straws.

Nesselrode Ice Pudding.

Dessert.

Coffee.

. . Toast List. . .

Proposer. *Responders.*
The King.
The PRESIDENT.

Success to the Royal West of England Academy.
Mr. Frank Dicksee, R.A. Mr. Ernest Savory.
(Representing the President of the
Royal Academy.)
Mr. E. Rimbault Dibdin.
(Representing the Provincial Art Galleries of the Kingdom.)

The Artist Members and Associates of the
Royal West of England Academy.
Sir Frederick Wedmore. Mr. F. A. W. T. Armstrong, R.B.A., R.W.A.
Mr. Alfred Parsons, R.A., R.W.A.

The Visitors.
Mr. C. Brooke Branwhite, R.W.A. The Rt. Hon. Lord Southwark.
Mr. Charles Helme.

The President.
Mr. Walter Crane, R.W.S.

GOD SAVE THE KING.

In 1913 the Academy's finances might be straitened, but Members knew how to celebrate. The inaugural banquet to mark the re-opening ran to thirteen courses and there were eleven speeches.

It was the dated art that Bristol deserved, but a century later who cares about whether a painting was old fashioned when it was done, provided it was good of its kind? Conservatism in art can sometimes be rewarded, and here, in the restored Academy's Yeatsian vestibules, it has been.

Between Two Wars

During the Great War, Bristol was geographically out of the danger zone, and hostilities had little direct impact on the RWA's annual exhibitions. Bristol's immunity to Zeppelin attack led the War Office to occupy several basement rooms, and there were tentative proposals to take paintings from the National Gallery in London for safe keeping.

If anything, the quality of work exhibited during the war years rose, as many London artists now submitted work to the west-country academy. The first two years of war saw 11,000 and just under 15,000 visitors to the autumn exhibitions, although receptions and other social events were discontinued for the duration. The galleries were now being unusually well used by artists, not only of the RWA but the Clifton Arts Club, and there were individual exhibitions, such as a joint show by Lewis Fry and Romilly Fedden. Donald Milner, when writing his brief history, thought that the 1914-18 years added to the reputation of the academy, which entered the 1920s in much better heart than it had seen out the old century two decades earlier.

There was some controversy, though, in the early post-war years when, in 1922, Council Chairman Ernest Savory invited the celebrated art critic of the *Observer* to contribute an article on the RWA's annual exhibition. PG Konody's criticisms proved unpalatable to some members and although the chairman defended his action, he did the honourable thing, falling on his sword and resigning the chairmanship after having served energetically but not entirely without conflict for some fifteen years.

The major developments of the inter-war years would prove to be the growing status of the art school under the tutelage of Reginald Bush [see page 76] and the establishment of the School of Architecture [see page 122]. Gordon Hake as head of the school, and Eustace Button as secretary, were the prime movers but the recognition of architecture's growing role in the Academy's activities was, perhaps, also indicated by the appointment of architect CFW Dening as the Academy's Hon. Secretary and his subsequent election as Artists' Chairman in 1934. A friend later said that this appointment was the proudest

moment of Dening's life. During his chairmanship, he treated everyone attending the annual dinner as a personal guest, giving each an appropriate gift, and he also paid for the Academy porters to be dressed in scarlet gowns and black velvet collars on the lines of the Burlington House banquets.

He had been a pupil of Henry Dare Bryan's, a local exponent of the Domestic Revival style and whose work, in addition to the 1909 alterations to the RWA building, included houses in Downs Park West and the Western Congregational College in Cotham. Like Dare Bryan, Dening went on to design some of the finest houses, as well as churches and public buildings, in Bristol. He was Bristol's most distinguished Edwardian architect, whose work ran the gamut of Arts and Crafts and neo-Georgian, and his Church of St Alban's in Westbury Park, 'with its bold and thrilling chancel' has been described by Andor Gomme as one of the best pieces of Arts and Crafts Gothic in England. He was responsible for the superb Savages' 'Wigwam' at the Red Lodge. Dening, who served his stint as President of the Bristol Society of Architects, was an 'architect's architect', much influenced by Edwin Lutyens. 'He subscribed to the principle of good manners in architecture,' Eustace Button later recalled, 'an attitude which felt it was bad form to design a building which flaunted its own individuality.'

Back of Assembly Rooms, Narrow Quay.
CFW Dening, w/c, 1941.

As well as being a practising architect who gave tireless service to the Academy, Dening was an accomplished watercolour artist, a keen member of Bristol Savages and president of the 'tribe' in 1928. In the war years he rose early to capture the pristine devastation of Bristol's bombed streets. Many of his watercolour drawings were executed, rapidly and intensely, as the fires still smouldered. The loss of so much fine architecture – and of a whole civilised way of life – broke his heart and, it was said, accelerated his death in 1952. Dening had an unrivalled knowledge of the seventeenth- and eighteenth-century buildings of Bristol and its environs and wrote a classic book on the subject. Inevitably, as an architect, he responded enthusiastically to the clean lines and comfortable proportions of Georgian architecture, then coming back into favour in the aftermath of the Gothic Revival.

Dening supported proposals for an International Architectural Exhibition and was greatly involved in the 'Art Treasures of the West of England' exhibition held in the Academy galleries in 1937. This major exhibition, with masterpieces lent from the collections of the Duke of Beaufort, Lord Methuen and the Earl of Bathurst prominent among many lenders, was well attended by visitors from all over the country. Despite this success, Council chairman Sir Frank Cowlin, speaking at that year's annual general

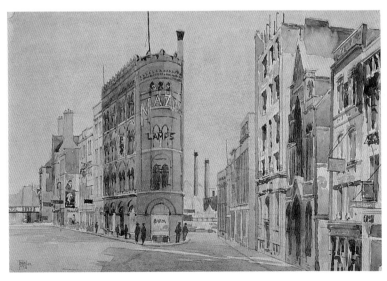

Victoria Street, CFW Dening, w/c, 1942.
[Both illustrations courtesy Bristol Museums & Art Gallery]

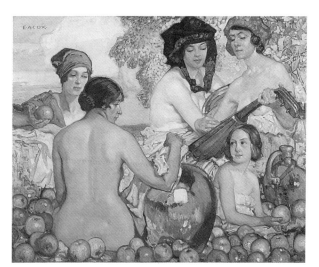

Ann's Youngest Daughter, by E A Cox. Donated in the 1930s, it was an early acquisition in the rebuilding of the Academy's Permanent Collection.

meeting, repeated a refrain that had echoed down the decades since the mid-nineteenth century: the lack of interest shown by Bristolians in the affairs of the Academy. The reality was that the Academy had up till then survived only by virtue of the patronage and generosity of a succession of lay-Presidents and other wealthy supporters. That imposing building standing at the junction of Queen's Road and Whiteladies Road was, to all intents and purposes, invisible to the great majority of Bristolians who rarely found their way to the affluent purlieus of the old city except perhaps for a bank holiday outing to the zoo on Clifton Downs.

In 1931, Bristol Art Gallery purchased outright the bulk of the Academy's collection which had been placed on 'permanent loan' in the municipal gallery. When tempted to think that the £10,000 which changed hands represented a bargain for the city, it is salutary to reflect that they could, for that amount, have instead put together a significant collection of still relatively under-valued avant-garde French paintings. As it was, the City Art Gallery's purchasing policy remained ultra-traditional until the advent of Hans Schubart as Director in 1953. The foundations of the City's fine collection of French paintings were then laid with the acquisition of works by Delacroix, Courbet, Redon, Vuillard and Seurat. It was not until 1960 that the public collection purchased its first post-Impressionist painting, by Roderic O'Conor and even that evoked criticism, as did the acquisition of Victor Pasmore's *Relief Construction* two years later.

The Academy Council did its best to encourage more visitors. One notable initiative was indeed an exhibition of modern French art, which was organised in 1930 with the assistance of the Alliance Française. Thousands climbed the marble staircase to be astonished by such unfamiliar artists as Bonnard, Derain and Dufy. Frank Rutter, in the *Sunday Times*, also drew particular attention to paintings by Dunoyer de Segonzac, Matisse, Paul Signac and Vuillard as opposed to masters like Cézanne, Degas, Gauguin, Monet, Renoir and Seurat whose work was also in the Bristol exhibition.

The *Observer* commented that the huge exhibition of nearly 300 paintings, sculptures, porcelain and other applied arts was an 'unprecedented and unique opportunity for an English provincial city to enjoy a general survey of French artistic achievement during the last half century even though no account has been taken of the more recent developments such as Cubism and Surrealism. No one should accuse the committee of timidity on this account. The education of a public nurtured on the enfeebled echoes of late-Victorian and Edwardian art must of necessity be a slow process. There is sufficient stimulation at this exhibition to arouse the provincial from complacent lethargy.' The organisers were wise, he added, not to force the latest experiments in abstraction for fear of producing too violent a shock.

Meanwhile, the Academy's artist members were expressing concern about the quality of work shown at their annual exhibitions. Their criticism centred on the apparent ease with which submissions of dubious amateur quality by subscribers (non-artist members, and forerunners of today's Friends) were accepted. The RWA's reputation was suffering, the artists argued, and subscribers should not expect preferential treatment. They wanted modern painters of distinction to be invited to exhibit.

As the *Observer* critic implied, the Bristol of the inter-war years was anything but a hotbed of progressive artistic taste, although in this it was doubtless typical of most provincial cities. In her study of Bristol Art Gallery 1905-1980, Karin Walton records that 'the Winterstoke bequest [of 1911] consisted primarily of the large-scale narrative pictures so beloved of the late Victorians and Edwardians. By this date they were already considered passé by connoisseurs but they remained popular with the majority of visitors into the 1930s. The activities of the Impressionists and post-Impressionists scarcely penetrated to Bristol, still less the products of Dadaism and Surrealism ...' Large historical set-pieces like Ernest Board's *The Departure of John and Sebastian Cabot on their First Voyage of Discovery, 1497*, painted in 1906, remained popular throughout the century and into the twenty-first.

The Second World War had a much greater impact on the RWA's activities than had the Great War, although at the outset Bristol was perceived to be reasonably safe from bombing attacks. The city was declared a 'neutral area', which meant it neither received evacuees nor were its own women and children evacuated to safety. All that changed with

US Army soldiers in the requisitioned Academy galleries during the Second World War.

the fall of France in 1940, which provided the German Air Force with bases from which it could target almost any town in the British Isles. Almost immediately sporadic attacks were made on industrial sites in the Bristol area, and in September a huge force of German aircraft executed a daring raid on the factory complex of the Bristol Aeroplane Company at Filton on the northern fringe of the city. The war had reached Bristol's doorstep.

In 1939, an exhibition of 130 watercolours of the English School had been well attended and the Academy's autumn exhibition was held as usual. The increasing threat of air raids saw the abandonment of exhibitions, and the galleries were soon to serve more war-vital purposes when they were requisitioned for use by the Bristol Aeroplane Company, and from June, 1942 the building was taken over by the Ministry of Works and Buildings for the BBC and the Postal Censorship departments which both needed housing. The Censors later moved out, to be replaced by the US Army. All the while, the School of Art continued to use their studios.

During the war years the Academy did little other than tick over, but the Council did not lose its historical perspective. The centenary was celebrated with a lunch in the Great Oak Room at the Red Lodge on Park Row on December 21, 1944, exactly one hundred years after John Harford had chaired the foundation meeting. The Lord Mayor and Lady Mayoress were chief guests and as a timely reminder of the importance of the Academy to Bristol life, an evocative letter written by Ellen Sharples to Philip Miles about the proposed building was read:

> If the Bristolians are only now liberal all preceding neglect of art will be forgotten – an elegant edifice will arise, an ornament and honour in the City, which within its walls will contain a succession of the various beauties of art … To Artists and amateurs it will be an especial advantage, inducing steady application and arduous exertion, so essential to the production of genius, and to all lovers of taste it will afford an elegant, ever varied and delightful source of amusement.

Much of Bristol's infrastructure was destroyed by enemy action, and when CFW Dening appealed for the release of the galleries immediately hostilities were over, he was given short shrift. The Inland Revenue, he was told, would occupy the premises until further notice. It was not until another five years had passed, and then only on the personal intervention of Prime Minister Clement Attlee, that the Council was able to re-occupy the building in October, 1950. The architect members, under the Honorary Architect, Tom Burrough, proved invaluable in guiding the post-war reconstruction of the galleries. The Academy, like most of Clifton, had avoided destruction but the roofs were badly damaged and there was superficial damage to the stone façade. The nearby Bristol Museum suffered a direct hit, among its losses a magnificent collection of fossils of ichthyosaurs and other prehistoric sea dragons. The City Art Gallery also suffered, but much less severely, and the picture galleries and their contents were undamaged.

Lord Methuen had become President just before the war, and with the reconstruction, was about to play a key role in reviving the Academy's fortunes.

John Codner's portrait of
Tom Burrough.
[RWA Collection, donated by
Mrs Helen Burrough]

chapter 11

A School for Architects

On May 19, 1920 the Bristol Society of Architects wrote to the Academy Council to propose the establishment of a School of Architecture attached or affiliated to the Academy. It took only two meetings between the two bodies for an agreement in principle to be reached. The School was to be known as The Royal West of England Academy School of Architecture, affiliated to the Architectural Association in London but under the overall control of the Academy's Council, with a special sub-committee with no fewer than six Fellows of the Society who would be elected as Artist Members of the Academy. The Society of Architects would assume financial responsibility and the direction of the curriculum. Messrs Cowlin and Fabian were elected to the Academy Council.

The School was formally constituted in January, 1921 with the opening ceremony conducted by the Prince of Wales. The new school followed the pattern of the Architectural Association School in London, which provided help with staff in the early days. For a period, the routine of the School was organised by the students, one of whom, Eustace H Button, served as Secretary. The limitations of part-time teaching staff commuting from London soon became apparent, and in 1922 a resident Principal was appointed. The School Council, confessing their inexperience in matters of teaching staff, left the choice to the students who, after consulting with the AA Students' Club, chose Mr Gordon Hake, who would direct and develop the School over the next thirty years. Hake started with just a dozen part-time students attending classes on two days a week for a three-year course. The School quickly established a reputation and by 1924 two students had passed the RIBA Intermediate Examinations, with one heading the national list. A RIBA Visiting Board applauded the School's standards and the School was commended by the International Conference on architectural education.

Three years later the School was looking for more space and the chairman, Frank Cowlin purchased the lease on 13 Charlotte Street which he proposed to sub-let to the School until the Academy could afford to purchase it at the price he had paid. It was

understood that when the School moved from Queen's Road it would retain its RWA title. Some years later, the School was on the move again, vacating Charlotte Street in favour of larger and more suitable premises, when the Chairman purchased No. 25 Great George Street for £2,131.4s.3d on behalf of the Academy to avoid the need for an overdraft. In 1937, twelve students gained certificates of exemption from the RIBA Intermediate Examination and one student won the RIBA 'Tite' Prize competed for by students throughout the British Empire.

The aftermath of the Second World War brought major changes. The School shared in the general influx of ex-service students, who provided a new impetus to the course. The new spirit was also felt in the relationship between the School and the Bristol and Somerset Society of Architects, on whose Council several members of staff served. The School became a meeting place for architects and students, which further served to bridge the gap between training and practice. The Academy acceded to its architecture arm's wish to enter into some form of affiliation with the University but was anxious that its links with the School should be preserved. Although, with the developing scope of architectural education, the School was by now conscious of an increasing financial burden, the Academy went into negotiations in a strong position, with growing demand for places and the School's accounts for 1949/50 showing a profit. While discussions with the university authorities proceeded, the Academy bought property at the rear of 23 and 25 Great George Street to provide much needed further accommodation.

The link with the University was formally established in 1951 and in the following year Evelyn Freeth, the Vice-Principal, was appointed Principal on the retirement of Gordon Hake. In his thirty years, the first principal had built up the establishment from an initial dozen students to well over a hundred full-time students attending a five-year course. It was a remarkable, if not single-handed, achievement for there had been a considerable voluntary effort by local architects and many friends outside the profession who had been inspired by Hake's leadership. In December, Eustace Button, as School Secretary, reported agreement that a Board of Architectural Studies would be set up to co-ordinate the curriculum, with two representatives nominated by the Council of the Royal West of England Academy 'who are to be regarded as the parent body of the School of Architecture'.

In 1958, The Royal Institute of British Architects adopted the policy that centres of architectural education should be totally identified with organisations of university level and the RWA School Council was encouraged to seek incorporation with the University. By 1961 the University of Bristol had formally proposed that the School of Architecture should be fully absorbed into the university, along with the establishment of a Chair in Architecture. There was at the time a second, recognised Department of Architecture in Bristol; technologically-based, this was part of the College of Advanced Technology, later to become the University of Bath. This was seen as complementary to the RWA School which was more fine arts-based.

There was fierce opposition from students and from local architects to the proposed transfer of the RWA School, opposition which was accentuated when the claims of the Principal, the popular Evelyn 'Bill' Freeth, to be appointed to the Chair were overlooked in favour of Professor Douglas Jones. The local press carried articles and letters of protest and, unhappily, personality clashes led to the early retirement of Evelyn Freeth, who had been designated Director of Studies. One bone of contention was that the University had sited the School in a faculty with a strong mathematical and science base. The School found itself operating like a faculty board but subject to ratification by one of three faculties – Arts, Science and Engineering – in rotation. Matters improved when the School became part of just two faculties, Engineering and the Social Sciences, and for ten years under this arrangement it enjoyed increasing success, with students gaining the RIBA design prizes in four years from 1968-71.

Professor Ivor Smith, who had succeeded to the RWA Chair of Architecture, wanted a studio-based design academy, with the stimulus of eminent architects as tutors. This did not fit well with the University's criteria of scholarship and academic excellence, and did not bode well for the future when the University Grants Committee intervened, imposing cuts throughout the university system. To maintain the highest possible academic standards, Bristol decided to make cuts selectively rather than across the board. Isolated, architecture could be closed with a minimum of pain to the rest of the university. There was an inevitable logic in such thinking, and despite protests from the RWA Council and the architectural profession, the fateful decision to close was taken in 1983.

For the remainder of the twentieth century, the Academy still nursed hopes of salvaging something for architectural training in Bristol, but when nothing came of the possibility that the Architectural Association (AA) School in London might open a Bristol branch, the curtain fell, at least temporarily, on a distinguished element in the RWA story.

All that remained was a legacy bequeathed by Charles Ruding Bryan to encourage architecture students, the income from which – between £2-3,000 per annum – has been redirected, via the 'Ruding Bryan Committee' set up by the Bristol Society of Architects and the University to purchase architecture books for the University library. The library is open to all BSA members. The committee meets twice a year, repairs ancient books and keeps the architecture library as up to date as it can within its financial limitations. The committee, to this extent, keeps the School alive.

chapter 12

The Methuen Years

Most people had other things on their minds when Lord Methuen was invited to be President of the Royal West of England Academy in July, 1939. Indeed, Lord Methuen had other things on his mind, since despite being well into his fifties, he rejoined his old regiment the Scots Guards very soon after the outbreak of the Second World War. The fact that he was absent, leaving to others the burden of arranging for the galleries' occupation by first the British Aeroplane Company and later the United States Army, was really no surprise to the Council. The role of the President, after all, had come to be seen as largely honorary, the main prerequisite of the holder being a healthy bank balance and generosity when it came to patronage of the arts. This function had been carried out admirably for the first 36 years of the century by successive members of the Wills family; it had begun in the previous century, in 1898, with Sir W H Wills, who became Lord Winterstoke, and was continued from his death in 1911 by the future Dame Janet Stancombe Wills. The four years between Dame Janet's death and 1936 had brought the presidency of her sister, the generous but rather less influential Mrs Yda Richardson; and for the three years preceding the offer to Lord Methuen there had been no President at all, Lord Waldegrave having declined the honour in 1938. No wonder, then, that the Council accepted their new figurehead's absence with equanimity. There was urgent work to be done, and in the fullness of time Lord Methuen would return from the war and everything would be back to the old routine; or so they thought.

They would find, over the years, that they could hardly have made a better choice, or brought in a more stimulating, questioning and demanding leader in the years of rebuilding after the war – one who knew all too well, from personal experience, about kicking over the traces and facing up to the inevitability of change. He also saw life from an artist's viewpoint, and that would make a deep mark on the running of the Academy.

Paul Ayshford, the fourth Lord Methuen, was born the son of a high-ranking Army officer and diplomat in 1886 and educated at Eton and New College, Oxford. Paul was

an honoured family name, Ayshford part of his mother's maiden name. The pinnacle of his father's achievement was to become one of the creators of the Union of South Africa in 1910. As Army Commander-in-Chief there from 1908 to 1912, his dual objective was to help bring Briton and Boer together and form the Citizen Army – a task he performed with such skill that he was made a Field Marshal in 1911. Four years later, in his 70th year, he was appointed Governor and Army Commander-in-Chief of Malta, where the main thrust of his work was to equip the island with hospitals and staff for the Dardanelles campaign. He died in 1932, when his son succeeded to the title.

Paul Ayshford, Lord Methuen.
[Photograph: Bassano Ltd.]

The Field Marshal had set a demanding standard, and although he served in both World Wars, Paul Methuen wisely chose a rather different path through life. Drawing and painting were interests from an early age, and before he left Eton he had had some academic drawings accepted by the Royal Zoological Society for its journal. His honours degree at Oxford in 1910 was in natural sciences, and on the strength of it he went to work for four years as an assistant at the Transvaal Museum in Pretoria. It was a pleasant, free-and-easy life of sunshine, privilege and artistic pursuit, but he did not shun the call to arms in 1914. After joining the Royal Wiltshire Yeomanry he moved on to the Scots Guards in France, where his pedigree saw him take the fast track to service as *aide-de-camp* to General Lord Rawlinson. In 1915 he also found time to marry the artist's daughter Norah Hennessy.

From the time he left the Army after the First World War his life was almost entirely that of a professional artist, though never in such a carefree fashion as in the inter-war years. As time went by he began to accumulate roles and responsibilities, of which the presidency of the RWA was just one; but in the 1920s he was simply happy to learn and practise his art, in which he succeeded with increasing acclaim as the 1930s progressed, and he was equally delighted to watch the blossoming of Norah's career as an interior

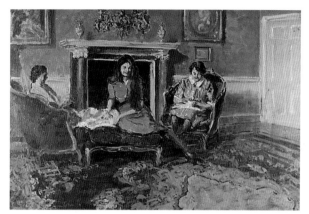

Conversation Piece, Lord Methuen, oil.
[RWA Collection, purchased 1954]

Rome: Piazza Popolo, Lord Methuen, w/c.
[RWA Collection, 1964]

designer. His skill as a painter of flowers, figures, landscapes and, most of all, the buildings of London, Bath and elsewhere, was such that he was able to command frequent solo exhibitions in the capital, most notably at the Leicester Galleries, Colnaghi's and Agnew's.

In 1927 he studied at Highbury Place, Islington under Walter Sickert, then a doyen of living British painters, though one with a chequered past. He had been a pupil of Whistler's, mixed with Degas and his contemporaries in Paris and had been such a frequent visitor to the red-light streets of London's Whitechapel around 1888 that a not altogether frivolous case has been made for his having been Jack the Ripper. That said, he was also earnest in his craft and began teaching in 1893, when he was still in his early thirties. Sickert was not nearly as grand as Methuen, or Methuen as bohemian as Sickert, but there are some parallels in their lives in the way in which each straddled the worlds of artistic freedom and serious scholarship. Lord Methuen's successor at the family home of Corsham Court, near Bath, his great-nephew James Methuen-Campbell, also believes Sickert was the formative influence on 'Uncle Paul's' style. 'He even followed Sickert's practice of working from photographs, on occasion. He produced a fine portrait of his grandfather, the second Lord Methuen, which is copied from a photograph, and is so similar to Sickert, both in the handling of paint and the general atmosphere and the effects of light, that one feels that it would be perfectly feasible to alter the signature without anyone being the wiser.'

As a young painter in the early years after the First World War, Lord Methuen had a number of advantages over others setting out on their artistic careers. For a start, he

Severn Beach in the 1930s, Lord Methuen, oil.
[RWA Collection, purchased 1966]

was not particularly young at all – over 40 by the time he was taking lessons from Sickert – and his wide experience of life, aristocratic assurance and wealth cushioned him from much of the self-doubt and hardship suffered by less well-connected painters. The deference he enjoyed and took as his right in his early years is hard to over-stress; on September 30, 1907, for instance, a procession through Corsham to celebrate his coming of age consisted of the Band of the 3rd Militia Battalion of the Wiltshire Regiment, the town's Troop of the Wiltshire Yeomanry, officers and members of the Royal Leet, the local fire brigade, tenants of the Corsham Court estate, tradesmen and the Church Lads' Brigade. On the other side of the coin, this almost Ruritanian aspect of his upbringing perhaps makes all the more creditable the manner in which he conducted himself as an urban mover and shaker in his later years.

When he returned from the Second World War – the 21st Army Group got it absolutely spot-on when it appointed him its Monuments, Fine Arts and Archives Officer in 1944 – he went about his task at the Academy with all the energy of one who felt he had to make up for six wasted years. May 1946 brought the resignation of the once-influential Artists' Chairman and Honorary Secretary, C F W Dening, and any fears of a power vacuum

were immediately quelled when Lord Methuen invited all Council members to a meeting at Corsham Court. With them went H W Maxwell, Director of Bristol City Art Gallery, and Donald Milner, Principal of the West of England College of Art; these two were very quickly co-opted on to the Council, with the professional arts administrator Maxwell becoming Acting Honorary Secretary.

The modernisation did not end there. Lord Methuen put in writing some of the principles on which he believed the Academy should be run. He specified that future selection and hanging committees should consist entirely of artists plus one architect, and that the RWA should welcome members from all parts of the country. He called for closer co-operation with the City Art Gallery and the Arts Council – and in a move that overturned consistent policy since 1844, he insisted that an academy of artists must have a majority of painters, sculptors and architects on its council. The rules were revised drastically to put this into place.

The overhaul of the RWA was not the only preoccupation of Paul Methuen in 1946, the year of his 60th birthday. The preservation of historic buildings was one of his great passions, and while the expression of this came nationally through House of Lords debates and the National Trust, he was equally eager to see Corsham Court restored for posterity after its wartime use by Westonbirt School. With the sole occupancy of the house by the family having been disrupted in this way, he was happy to continue living in the west wing while part of the Court was taken over by the Bath Academy of Art; this continued there until 1986, most notably in the years in which its founder, Clifford Ellis, was Principal. Bath School of Art, at which Lord Methuen's old mentor Walter Sickert had been a teacher, was destroyed by bombing in 1942, and the opening of the BAA at Corsham four years later was the realisation of a dream for Ellis, his staff and students. It was also a vital financial aid in Lord Methuen's battle to conserve the house and its treasures. He and Norah soon got used to their young neighbours, who in turn look back with affection on their time at the Court, which was a royal manor in Saxon times and is now based on an Elizabethan house dating from 1582. It was bought by an earlier Paul Methuen in the mid-eighteenth century to house an ambitious collection of sixteenth- and seventeenth-century Italian and Flemish Master paintings and statuary, while in the middle of the nineteenth century it was altered to receive a second collection of

fashionable Italian Masters, rare primitives and stone inlaid furniture. Works by Adam, Chippendale, Lippi, Rubens and Van Dyck are to be found in a collection which Lord Methuen took great delight and care in chronicling and restoring. He made it his study to display its treasures to their best advantage and have them authenticated by the most knowledgeable scholars in the land. He also enjoyed showing students around the picture gallery, a beautiful triple cube of a room 72 feet long; the intricate plasterwork of its ceiling is mirrored in the pattern of the carpet designed by him and made in 1959 by the royal tapestry factory in Madrid. Elsewhere he supervised the repair of crimson silk damask curtains and wall hangings, inevitably with Norah's professional guidance. She died in 1958, and a remarkable full-length alabaster statue of her can be found in Corsham Church.

Students – and staff members who included Terry Frost, Howard Hodgkin and the late Peter Lanyon – also look back with wry affection at Corsham Court's peacocks, as noisy as they were beautiful. In 1965, neighbours beyond the walls complained to the parish council that their screeching had reached unacceptable levels, but whatever was said or done at that time, they survive to this day. In fact the parish council, 50 years from that extraordinary 21st-birthday parade, seemed to take some pride in being spikily independent of undue influence from the Court. In 1963 it was happy to receive a Methuen painting of Corsham High Street – 'valued at £120 for insurance purposes' – to hang in the Town Hall; but in 1953 it had not hesitated to reject His Lordship's plans for a bus shelter to stand outside the Town Hall, complaining that it 'cut out too much light'. Happily, his creative talents were appreciated elsewhere, and after being elected an Associate of the Royal Academy in 1951, he became an Academician in 1959. Lord Methuen was also a Fellow of the Society of Antiquaries and served as a trustee of the National Gallery, the Tate Gallery and the Imperial War Museum. He was a member of the Royal Fine Art Commission from 1952 to 1959,

Interior, 8 Fitzroy Street,
Vanessa Bell, oil. [RWA Collection, 1953]

Palace Square, Copenhagen, Duncan Grant, oil.
[RWA Collection, 1956]

Hop Alley, William Townsend, oil.
[RWA Collection, 1953]

and counted among his other interests botany, gardening, architecture, Freemasonry and the restoration of the now flourishing Kennet and Avon Canal.

As for the Royal West of England Academy, one of his first concerns, leaving aside the restoration of the galleries after their military occupation, was to rebuild a roll of artist members that had been hit badly by the war years. His solution was for the Council to boost both numbers and the Academy's reputation by electing a score of leading artists to come aboard, among them Duncan Grant, Vanessa Bell and a future Academy President, Bernard Dunstan. The Grant-Bell connection was an early and brilliant example of the advantages to the Academy of a President who moved easily and confidently among big-name painters who interested and intrigued the public. An exhibition of Bloomsbury art in 1962 would be one of the great triumphs of the Methuen years, and the President and Honorary Secretary, Donald Milner, felt like children let loose in a sweet-shop when they were invited to Charleston, the remarkable Grant-Bell house in Sussex, to select the paintings to be shown in Bristol. Their choice filled the main galleries while there was further impressive work on show by two of their circle, Dorothy Larcher and Phyllis Barron. A painting by Vanessa Bell had become part of the Academy's permanent collection in 1953, in a morale-boosting spending spree through the Talboys Fund which also saw the acquisition of works by Claude Rogers, Malcolm Osborne,

Patricia Ramsay, Helen Binyon, William Townsend and Peter Potworowski – a list which smacked strongly of the Corsham Court art college. Four years later, the fund enriched the RWA collection with a fine clutch of paintings by Dod Procter, Carel Weight, Julian Trevelyan, Bernard Dunstan, Robin Darwin and Mary Fedden, another giant in the history of the RWA.

The Convalescent, Bernard Dunstan, gouache.
[RWA Collection, 1951]

Lord Methuen's position at the Academy was strengthened considerably in October, 1952 when he took on the added responsibility of Artists' Chairman on the retirement of Sir Lionel Taylor. As the years went by – he was, after all, aged 70 by 1956 – he concerned himself less with the day-to-day conduct of the RWA, and in particular the structural and financial problems that frequently beset it; but his familiar figure, hawk-like and as often as not swathed in a cape, was a familiar sight around Queen's Road almost to the end.

The early 1950s, with the reopening of the galleries at a cost of £14,000 and a new sense of 'artist power' ushered in by the President, were heady and exciting times. Lord Methuen was at his most 'hands-on', throwing himself into the humblest of tasks, sometimes with Norah beside him, and especially loving the bustle and sense of anticipation of hanging days. He used his clout to help bring in some influential names as Vice-Presidents – the Duke of Beaufort, Sir Robert Witt, Professor Frank Dobson and Sir Philip Morris, the Vice-Chancellor of Bristol University. Artist majorities on the Council were all very well, but he knew that the support of powerful public names was still essential.

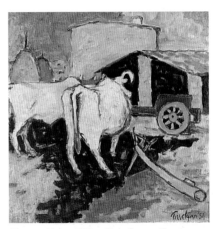

Tuscan Farm, Julian Trevelyan, oil.
[RWA Collection,1953]

The Academy's stock was rising, as instanced by an anecdote concerning the artist Duncan Grant. Invited at the same time to accept membership of both the RWA and the Royal Academy, the famous 'Bloomsberry' chose the RWA, saying it gave him the greater pleasure.

Corner of Dowry Square,
Raymond Cowern, w/c. [RWA Collection,
1949]

Bunch in Black Pot, Dorothy Larcher, oil.
[RWA, gift of Robin Tanner]

1951 saw the Annual Exhibition held at the Academy for the first time since the war. Some 550 works were on show, nearly twice as many as could be shown in the City Art Gallery, where the previous year's exhibition had been staged. An unusually large number of works – some 1,170 – had been submitted, suggesting, on the face of it, that things were more or less getting back to normal. There was a strong contingent of London artists, including Cosmo Clark, sculptors Frank Dobson and Richard Garbe, Sylvia Gosse, Henry Lamb and Gilbert Spencer. Despite this metropolitan presence, the *Western Daily Press* critic could report, reassuringly, that 'the violent modern style of painting is on its way out, and there is not one exhibit that is not easily recognisable.' He went on to highlight work by the idiosyncratic Doris Hatt and a young Mary Fedden.

But with artist members pressing for more and even better exhibitions, the Honorary Treasurer of the time was obliged to tell the Council that the Academy was losing money, living beyond its means, and facing a substantial deficit of £1,500 a year. To increase revenue, exhibition space was given over to external functions, which would include sales of work, mannequin parades, University examinations and various charity functions. Useful though these were to a hard-pressed treasurer, they inevitably impeded the intended use of the galleries.

In 1952, the Academy held its one-hundredth exhibition, and an annual dinner on the evening before the private view. This was another initiative on the part of the President, who saw the value of Subscribers to the Academy and insisted on a joint social occasion rather than the artists' informal supper which had been the pre-war practice.

The worth of the President's drive to involve lively lay members became apparent almost as soon as Professor W Mc C Stewart

joined the Council. His links with the Alliance Française brought the opening, just days before the Coronation of 1953, of the superb exhibition 'English Painters in France'. The French cultural attaché in London paved the way for works from the Louvre and Versailles to be brought over, and there was a flurry of interest in paintings by Turner, Bonnington, Cotman, Crome and a wide range of recent and living artists. There was also, at the end of it, a depressing and serious loss of £250 – a reminder to Lord Methuen and his

Magnolia at Corsham, Lord Methuen, oil. [RWA Collection]

colleagues of the realities of life in a Bristol in which public apathy towards the visual arts was never far below the surface. Two years later, an excellent 'Art of the Theatre' show – with original designs for masques by Inigo Jones, Diaghilev's Ballets Russes *et al* – made a similar loss. Although doing no good for the financial balance sheet, such initiatives brought intangible benefits, adding to the Academy's goodwill and underlining a continuing commitment to enhancing the region's cultural life.

The President recruited Marguerite Steen, the popular author of *The Sun is My Undoing* and other books about her imaginary Bristol family, the Floods, to help a financial appeal. In a pamphlet circulated to local businesses, she wrote that 'the Academy represents the rich and famous resources in art of the whole of the West Country … It is part of the credit of the city itself; part of the personal credit of every man of Bristol. Bristol has suffered the loss of many of its material beauties [in the war]; it cannot afford the loss of something that stands for the beauty of the Spirit.'

Marguerite Steen was guest of honour at the annual dinner in 1953, while John Betjeman (although a popular poet and noted architectural commentator, not yet the national TV pundit and cult figure he was later to become) was invited to open the exhibition. He added his weight to the plea for support, extolling the virtue of artists in the wider community. 'Artists are the most valuable people we have. The witnesses of a civilisation are our buildings, primarily, and after them our pictures and then our literature. If our civilisation is to be remembered it is by our art.' Artists had to live, he

John Betjeman advised exhibition-goers to 'buy Bristol'.

said, and it was just as cheap to acquire an original painting at the exhibition as it was to buy a reproduction of Van Gogh. 'Do buy pictures,' he urged his audience. 'Artists must be kept alive. There is a terrible tendency to buy a reproduction of Van Gogh's *Sunflowers* and put it up over the electric fire and think, "There is art catered for". How very much better to buy the work of a Bristol artist.'

Public taste reared its head when crowds flocked to the Academy in 1955 for a chance to see Pietro Annigoni's portrait of Her Majesty the Queen, underlining the RWA's problem of how to accommodate popularity while aiming for the highest possible standards in contemporary art.

Crafts had not featured greatly in the Academy's scheme of things, an omission which was corrected in 1957. An ambitious show of work by artist-craftsmen – ceramics, furniture, textiles, silver and calligraphy – attracted good attendances and sales and, to the Treasurer's relief, there was no financial loss. This exhibition set a precedent which was to be successfully followed in the years to come. The following April saw another significant exhibition, this time of contemporary artists, with paintings by Ruskin Spear, Philip Sutton and Keith Vaughan and sculpture by F E McWilliam.

But while artistically the Academy was flourishing, financial worries were never far away. The dome above the gallery entrance was found to be in a dangerous state of decay, and its complete reconstruction cost very nearly £3,000. The Council grasped the financial nettle. A major appeal brought in much needed funds, with a number of prominent local firms agreeing to subscribe annual sums under covenant, and every Artist Member contributed a painting for sale on the Academy's behalf. An exhibition of this work in 1963 boosted the exchequer, and several new subscribers gave substantial sums. It was a timely rescue, and the RWA narrowly averted disaster.

Lord Methuen's 80th birthday in 1966 convinced him it was time to make way for new blood. Donald Milner took over as Chairman in the following year, while on January 1, 1972 Sir Robin Darwin succeeded Methuen very briefly as President. Lord Methuen died early in 1974, and Sir Robin very shortly afterwards. The Academy had staged a major Methuen retrospective exhibition in 1970, a gesture much appreciated by the artist.

The funeral at Corsham Court brought in hundreds of mourners. There was a strong contingent of Royal West of England Academy members and other artist friends from far and wide. Locally, the parish council paid tribute to the man who restored much of the Court to the benefit of the community; but there was always a great deal more to Paul Ayshford Methuen than that, and other tributes poured in from a wide spectrum of society.

And what of his impact on the Royal West of England Academy? It is difficult to exaggerate the sense of purpose and destiny he ushered in after the Second World War, and the power of the new broom that swept away so much stagnation and complacency. Those who knew him first-hand had their own memories, but it is hard to better the verdict of Donald Milner, his loyal right-hand man for so many years, when he said: 'Since the appointment of an artist, Lord Methuen, as President, it has been demonstrated that the Academy's reputation can be maintained only by artists – by men and women painters, sculptors and architects of integrity.' That was a lesson well worth the learning.

`A New Spirit is Abroad'

In common parlance, Lord Methuen was 'a hard act to follow', but his successors were able to build on the sound foundations he had laid for a world which had changed almost beyond recognition since the drab post-war years in which he had set about restoring the Academy's fortunes.

With Donald Milner as a strong President in the second half of the 1970s, the Academy's artist members were given greater prominence through a popular innovation: regular 'one-man' or small group exhibitions by artist members. An early such exhibition included, in 1975, Peter Coate, Anne and Jerry Hicks and Robin Tanner. This format continued very successfully in the following decades. At the same time, the Academy opened its doors to exhibitions initiated by other bodies – such as the South West Arts' 'Four on Tour' exhibition of 1976 which brought work by Peter Eveleigh, Michael Gaston, John Hoyland and sculptor Paul Mount to Bristol, followed by Terry Frost in the same year.

This new-found vigour could be seen in the impressive list of exhibitions held in the closing decades of the twentieth century and into the twenty-first. The successor to Donald Milner as Artists' Chairman in the mid-1970s was Ernest Pascoe, a member who devoted much effective energy to the Academy and was to hold many senior posts. He in turn was succeeded by Jerry Hicks, another Chairman of immense commitment and charisma, who has served not only the Academy but also the city of Bristol, notably through his tireless commitment to the work of Bristol Civic Society. One highlight of these years was a memorial exhibition to William Townsend, a stalwart supporter of the Academy, which was arranged by George Sweet and opened by Sir William Coldstream in 1978. Other notable memorial exhibitions included one to the popular honorary secretary, Gerald Scott, which paid tribute to his varied talents in the fields of sculpture, draughtsmanship and print-making.

The Academy has since been served by a succession of excellent Artists' Chairmen, of

The Academy galleries in the 1990s.

Elsie, Ernest Pascoe. [RWA Collection]

Carmen, Gerald Scott,
ciment fondu.
[RWA Collection, 1962]

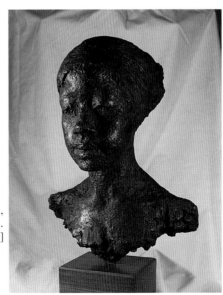

President Mary Fedden with Sir Hugh
Casson PRA and Lady Casson.

Eyot Gardens, Mary Fedden, oil.
[RWA Collection, 1957]

whom Warren Storey, with his many years of dedication to the Academy cause in various capacities, could be considered an exemplar. As well as single and small group shows, two notable exhibitions curated by artist-member Jean Rees during her energetic term as Chairman in the early 1990s were 'Scottish Art in the 20th Century' – one of the largest exhibitions of Scottish art organised outside Scotland – and 'Artists from Cornwall'. Both were highly successful and in each case local publishers Redcliffe Press were commissioned to produce associated publications, with essays and biographies, to commemorate these important exhibitions. With the presidency now constitutionally always in the hands of an artist, the position of Artists' Chairman might now have seemed superfluous. The reality was that, with only a small paid Academy staff, a good chairman was indispensable not only in chairing exhibition and hanging committees but subsequently in handling the detailed arrangements for the exhibitions.

As ever, some exhibitions proved more popular than others. A retrospective show of more than 200 works by Mary Fedden in 1996 was an outstanding sell-out event, while the more demanding exhibitions, although well received critically, often did not attract the visitor numbers they deserved, raising the old spectre of Bristol's indifference to fine art.

The annual exhibition was all the while going from strength to strength. The metropolitan influence of Bernard Dunstan and Mary Fedden, both of whom brought prestige during their presidencies, was important in the 1980s. At his election Bernard Dunstan had said that he saw no particular need for innovation and saw his job as 'keeping things going rather than making changes'. But he brought with him a feel for

artistic direction, and instituted Varnishing Day prior to the opening of the Autumn Exhibition, an occasion which proved popular, giving exhibitors a chance to meet and talk. Mary Fedden, in her turn, was instrumental in attracting 'big name' exhibitors such as Elisabeth Frink, Elizabeth Blackadder, Hugh Casson and Leonard Rosoman. She was also the first President whose election conformed to a new protocol of discussion and vote by the Academy's Council. She was elected by an overwhelming vote. In the past, Presidents had emerged, rather like old-style leaders of the Tory Party, often on the introduction of an outgoing President or other senior members, and the appointment, by the time it came to be formally considered, had been more or less a *fait accompli*.

Louise, Bernard Dunstan, oil. [RWA Collection, 1972]

Another constitutional change, first proposed in 1986 by the then Treasurer, John Gunn, saw the Subscriber class of membership, which had effectively been stripped of real influence by Lord Methuen in his sweeping post-war changes, replaced by the Friends of the RWA. This body, which is now financially independent of its former parent body, has gone from strength to strength, stimulates interest in the Academy's activities with an attractive newsletter, lectures and tours and is a valuable fund-raising adjunct to the Academy. In 1993, the members voted to abolish another category of membership, that of Associate, and all Associates then became full members and were designated RWA.

The Academy's 150th anniversary year, 1994, under the chairmanship of William Cooper, saw a flurry of imaginative exhibitions. The National Westminster Bank sculpture competition threw up a splendid winner in Georgina Redfern's *Time and Tide* which now stands outside the NatWest Life Building on Trinity Quay in Bristol. Among a dozen exhibitions, gallery-goers could enjoy Picasso etchings, paintings by William Tillyer, Joan Miro prints and an open print exhibition, while Reg Gammon had the unusual distinction of attending his own centenary exhibition. The President, architect Leonard Manasseh, curated an exhibition of architectural work of his choice. That year's Autumn Exhibition was, as ever, very popular, with the added attraction of two

Still Life with Black Sash, Elizabeth Blackadder, w/c. [RWA Collection, 1988]

watercolours by the Prince of Wales. A commemorative supper organised by the Friends of the RWA for Council members also served as a useful bonding exercise. During the year, Jean McKinney, Organising Secretary, was made an MBE, a well deserved acknowledgement of her service to the Academy. She had been a worthy successor to Aileen Stone, who had administered the Academy almost single-handed since 1950 before handing over to Miss McKinney in 1974, and had been rewarded with the appointment of Honorary Vice-President on her retirement. Rachel Fear, who succeeded Miss McKinney, was made an honorary RWA member on her retirement from the Academy staff in 2002.

Successive Presidents and Artists' (latterly known as Academicians') Chairmen were pushing at the boundaries, arranging innovative exhibitions and seeking to dispel the 'gentlemen's club' image which many people had of the Academy. This was a particular concern of Peter Thursby, President from 1995 to 2000, who responded enthusiastically to the opportunity to participate in the highly successful Bristol Doors Open Day, when many hundreds of local people saw inside the building for the first time. It was a modest

Georgina Redfern's award winning *Time and Tide* now adorns Trinity Quay, Bristol.

departure, but symptomatic of a new mind-set in the Council of the Academy. 'When I took over in 1995, I soon became aware that if we were to survive into the twenty-first century, there had to be a change of attitude. We had to offer the public a better welcome, a proper restaurant, auditorium, a fine art shop and a web-site. We needed business experience and good fund-raising.'

The Academy had struggled along on admission charges, commissions, rent, the sale of catalogues and bequests. But more was needed, and this meant not only raising funds on a greatly enlarged scale, but broadening the Academy's appeal to the wider Bristol and regional public. The Academy had shown that it was in the forefront of presenting good art; it now had to present itself and do that in new and attractive ways.

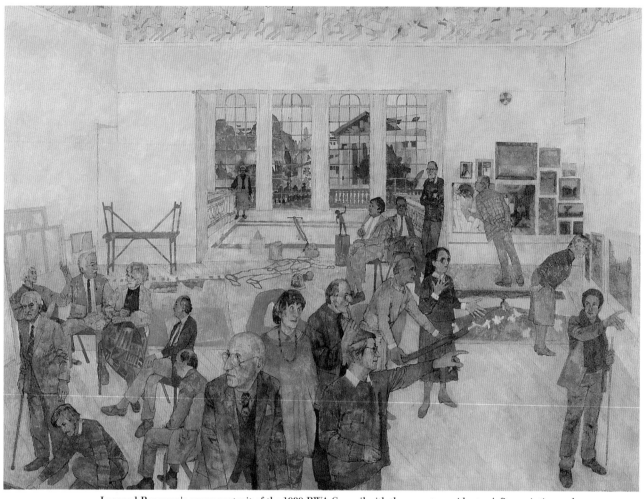

Leonard Rosoman's group portrait of the 1989 RWA Council with three past-presidents. A fine painting and an important historical document, commissioned at the suggestion of the then President, Leonard Manasseh.

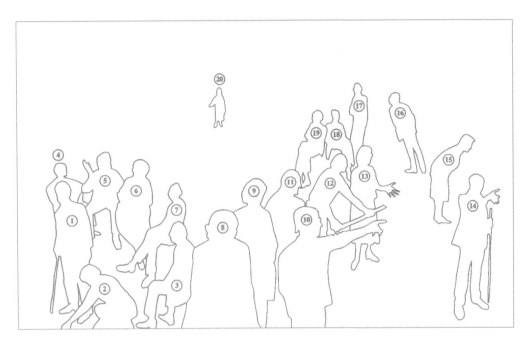

1	Donald Milner PPRWA	8	Leonard Manasseh PRWA	15	Aileen Stone
2	Kenneth Oliver	9	Mary Fedden PPRWA	16	Eustace Button
3	Arnold Wilson	10	Bernard Dunstan PPRWA	17	THB Burrough
4	Le Clerc Fowle	11	Peter Folkes	18	John Gunn
5	Warren Storey	12	Denys Delhanty	19	John Keeling Maggs
6	Jean Rees	13	Margaret Lovell	20	Jean McKinney
7	Peter Thursby	14	David Carpanini		

Plage de l'Abbaye de St Jacute de la Mer,
Leonard Manasseh, w/c & pencil.
[RWA Collection, 1988]

Landscape with Blue Donkey, Reg Gammon, oil.
[RWA Collection, 1984]

Windows in Space, Peter Thursby, brass.
[RWA Collection, 1993]

The Academy's profile was helped by generous television coverage including an HTV film, *Rolinda Sharples: Painter of History* and, in 1998, *Academy* which included interviews with leading Academicians and contributions by the critics David Lee and Brian Sewell.

This expansionist atttitude was carried forward by Derek Balmer, who took over as president in 2001. Derek Balmer had served as Artists' Chairman with distinction, enhancing the Academy's reputation through a programme of exhibitions of leading contemporary artists such as Maurice Cockrill, Albert Irvin, Michael Kenny, Michael Porter and Bristol-born Richard Long. One of his first initiatives on becoming President was to invite artist-member Alfred Stockham to become curator of the Permanent Collection, with the immediate objectives of fully documenting and assessing the condition of well in excess of one thousand paintings accumulated through the Academy's enlightened policy of purchasing significant exhibition work by Academy

Passing Storm, Hotwells, Alfred Stockham, oil.
[RWA Collection, 1997]

High Summer, Derek Balmer, oil. [RWA Collection, 1996]

members. As a direct result of this acquisition policy, begun in earnest under Lord Methuen in the early 1950s, the Academy now had a representative, and increasingly important, collection of figurative British art of the second half of the twentieth century.

George Ferguson, who was to be elected President of the Royal Institute of British Architects in 2002, had by now joined the team as Honorary Architect, with the vision of 'a great new resource for Bristol, with a newly landscaped and restored frontage liberated of its cars (banished to the rear) and opening its doors all year round. The lower floor, which is currently the 'dead space' of the permanent collection store, will house the new multi-purpose auditorium for films and lectures for up to 150 people.' There would be a sculpture garden, and a café would add vitality and enable the balcony terrace, partly enclosed for all-year-round use, 'to entice the stream of passers-by who have never set foot in the place and who have never experienced the magic of the gallery.'

The Academy was moving into a critical stage of its development with a team of dedicated professionals able to address a variety of issues and problems. Another key member of the Academy team, Peter Stoppard brought to the treasurership an energy and inspirational understanding of the needs of an arts institution – and of its members – that went well beyond the requirements of the post.

An appeal was launched in 1998 to raise £5 million to repair and modernise the Academy's Grade II* building, provide a lecture theatre and café/restaurant, restore and conserve the impressive permanent collection and extend its activities. With English Heritage grants, corporate and private donations and considerable financial and other assistance from the University of the West of England, vital restoration work, overseen by architects Acanthus Ferguson Mann, could at last be put in hand. By autumn 2002, the first phase was complete, with roof restoration, masonry repairs and remedial work to John Evan Thomas's outstanding statuary. Corrugated asbestos-cement sheeting, which had replaced war-damaged slate, was stripped away and the galleries re-roofed in natural slate, with the roof-lights re-glazed with laminated UV filtering glass. Other works included stabilising the two chimney stacks, remedial work to the dome, including a new glazed lantern, and re-decking and paving the balcony in natural York stone slabs. Much of this essential work was not visible to the public, but passers-by and visitors would notice the dramatic effect of the cleaning and restoration of the façade

and its sculptural work. Inside, the Walter Crane murals, water-damaged by roof leaks, were restored and conserved to their pristine brilliance.

The next phase, when the funding was in place, would constitute the great leap forward. Improved climatic controls to regulate temperature, light and humidity would mean that the galleries could host ever better touring exhibitions; this, and the proposed enhanced facilities, would attract more visitors. An application to the Heritage Lottery Fund, which would require the RWA to raise matching funding, was being finalised in 2002.

Designer Tony Baldaro was commissioned to update the Academy's communications by way of literature and graphics, while the Academy's web-site, created by UWE's Faculty of Art, Media and Design as part of the new collaboration, was a model of its kind. With profiles of all RWA members, and examples of their work, it served to present the Academy worldwide.

One commentator in 1998 thought the Academy something of a paradox. 'On the one hand, it is seen as 'The People's Gallery' where in the annual exhibition any artist has the opportunity to show and sell their work in some of the finest galleries in the country; and yet at the same time it is perceived as an exclusive and slightly stuffy institution which has more in common with a Victorian merchant bank than a contemporary gallery – and not seen at all by too many.' Another, a practising artist, commented acutely: 'If you fail to get a picture into the famous London academy show, then you cross your fingers that Bristol will accept your work. It really looks good on your c.v.' The painter Maurice Cockrill, who had a solo show at the RWA in 1998, felt 'tremendous pride and anticipation at the prospect of having my paintings displayed in such fitting, finely proportioned and well-lit galleries', while Flavia Irwin thought '… the galleries are so grand in size and proportion that pictures of whatever scale respond to them.'

In 1999, the Academy was honoured by a royal visit – the first since King George V in 1913 – when HM the Queen toured the galleries, talked to assembled members and guests and watched displays by children. The President, Peter Thursby, presented Her Majesty with one of his sculptures.

Just over 8,000 people attended the Annual Exhibition in 2000, while total visitor numbers for the year, at 18,387, were nearly double the levels two, three and four years

RWA Under Wraps, 2002. John Palmer's record of the restoration work in progress.

Conserving one of the Walter Crane lunettes.
[Photograph courtesy: Stephen Morris]

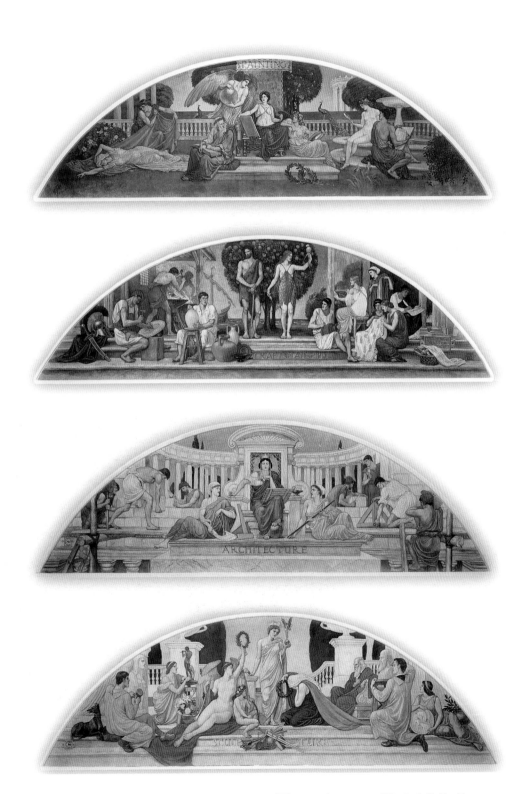

The Walter Crane lunettes after conservation. [Photographs courtesy: Elizabeth Holford]

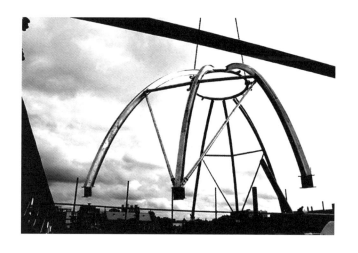

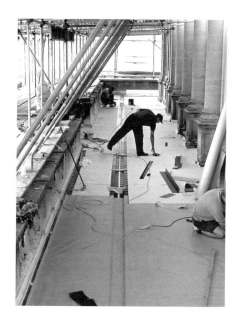

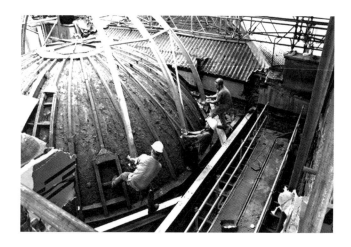

Restoration work in progress.
[Photographs courtesy Acanthus Ferguson Mann}

earlier. With a press-inspired interest in the new phenomenon of 'Britart', rising attendances might be expected, but on the other hand the Academy, which had to charge for admission, now had to compete for visitors not only with Bristol Art Gallery and Arnolfini but a growing number of commercial galleries both in Bristol and in neighbouring Bath. When asked about this competition, Derek Balmer saw nothing but good in the proliferation of opportunities to see and buy contemporary art, and reiterated his determination to see the Academy working more closely with Bristol Art Gallery and Arnolfini, both of which he considered as complementary rather than in competition, and with South West Arts.

The dramatic improvement in Academy attendance figures could be attributed to a combination of factors: more focussed marketing and publicity, the Appeal and a lively programme of exhibitions. Constrained by its physical limitations, the Academy was still not realising anything like its full potential, but the figures were encouragingly moving in the right direction. The planned improvements, when funds permitted, would doubtless further transform visitor numbers.

With the galleries closed for restoration, the only exhibition at Queen's Road in 2002 would be the annual show, but 'All at Sea', an 'outreach' exhibition by academicians on a maritime theme was held at the @t Bristol complex on Harbourside. Academicians' Chairman John Huggins was all the while devising exhibitions for 2003 and beyond, with planned shows including Euan Uglow, to be curated by William Darby, Alastair Michie, a travelling exhibition of YBA prints by Tracey Emin,

Her Majesty Queen Elizabeth shares an architectural joke with George Ferguson, as President Peter Thursby looks on ...

... and meets members and staff. Here, Her Majesty talks with Academy Secretary Rachel Fear and Hon. Treasurer Peter Stoppard. George McWatters, then Chairman of the Appeal Committee, flanks Rachel Fear, and Alfred Stockham is beside Peter Stoppard.

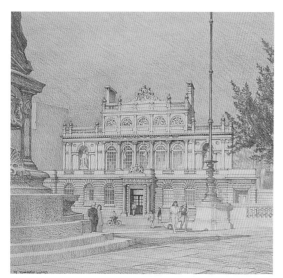

The RWA, Michael Hitchings, drawing.
[RWA Collection, 1998]

Morning, La Guerite, Jerry Hicks. [RWA Collection]

Baccarat, John
Huggins,
bronze.
[RWA
Collection,
1998]

Damien Hirst, Rachel Whiteread and others, Bristol Schoolchildren's Art and the Academy's fourth Open Sculpture Exhibition.

Interviewed for the Friends' newsletter in Autumn 2001, John Huggins had presented the Academy's vision for the future. Open every day, the RWA would be a busy place with a lively programme of exhibitions, lectures and workshops. Visitors would make their way to the Academy for a multitude of reasons: to view the current exhibition, buy a picture, visit the gallery shop, inspect the permanent collection, attend a lecture, or meet a friend for coffee. There would always be something to do or see. The RWA would be a much talked about place and an important landmark in the cultural landscape. A small part of that vision would be realised in 2003, when the adaptation of the Council Room to serve as a small commercial gallery for hire would mean that the Academy would be open more or less permanently throughout the year.

A major signpost to the future was the first RWA Open Painting Exhibition in 2001. Writing in the catalogue, critic Hugh Adams thought there was a time when the words 'academy' and 'open' would have been considered contradictions. 'In the popular, and even informed mind, academies of art were exclusive and even defensive entities not much given to debate about what constituted 'Art', for they *knew*. That has changed and academies, in England at any rate, seem to be reverting to their original function as places for discourse, discussion and debate ... The general standard [of the work on show] is very high and

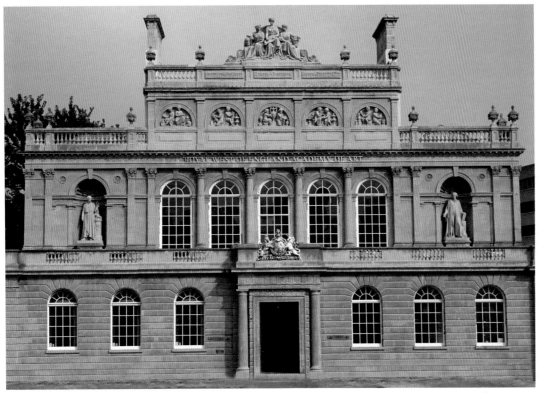

The Academy building, September 2002. [Photo: courtesy Stephen Morris]

certainly suggests that the decision to add an Open Painting Competition to the Sculpture and Printmaking ones which now exist is, in terms of quality alone, amply vindicated.'

He concluded that 'a new spirit is abroad, one in which it is ... certainly impossible to assert that "Painting is Dead"; one in which this academy has commendably and in a spirit of openness and transparency, not to say generosity, opened its galleries to all and of course this results in a greater sense of "ownership" by the local community, one in which appeals, such as the one resulting in the present veil of scaffolding, are generously met. This is the spirit in which there is a genuine preparedness to collaborate with cultural institutions that in the past might have traditionally been regarded as "the enemy". It is a spirit in which a whole region is encouraged to recognise the beauty and value of a suite of galleries of which any city might be proud and as a consequence help secure their future.'

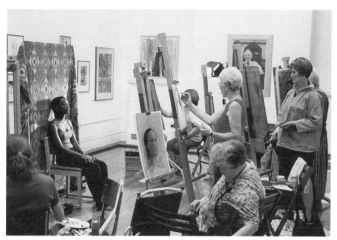

Portrait workshop: August, 2000.

Remarkably, through thick and thin, the Royal West of England Academy has remained self-supporting for over 150 years and has not only maintained but in recent decades demonstrably enhanced its status as a 'centre of excellence'. Just as the city of Bristol now displays a new-found – or perhaps more properly a renewed – sense of confidence, it is not fanciful to suggest that this evolving institution is about to move into what will prove to be its greatest years.

Terry Setch exhibition, 2001: children's recycling workshop.

The Permanent Collection

A cross-section of modern British art

The Academy houses a growing permanent collection of some 1,300 works of art. It was given a good start with Ellen Sharples' gift of her collection of pastel portraits and her daughter Rolinda's paintings in 1847, which was supplemented in the 1850s when the President, JS Harford, presented Jacob Jordaens' superb *Nativity*, painted around 1663, and, after acquiring it for a nominal sum, Thomas Proctor deposited Hogarth's vast triptych from St Mary Redcliffe church. Many other gifts followed, but such largesse in time came to present problems of access and display. Eventually, the Academy's collection, without the Hogarth, was handed over on 'permanent loan' to the new municipal gallery which opened in Queen's Road in the early years of the twentieth century. The move was welcomed by the local press, which congratulated the Academy on awaking from 'the lethargy into which it had gradually sunk, and [commencing] to put its house in order'. It seems that the Sharples pastels and paintings had been languishing in the Academy's cellars, only occasionally seen by members let alone the public.

This loan was made in return for a commitment by the city council to spend at least £500 each year on purchases from the Academy's annual exhibition: a move designed to benefit academy artist members while enhancing the city's collection. The Art Gallery curator found some difficulty in honouring this commitment – there was not always work thought to be of sufficient quality – and eventually, in 1931, the arrangement was abandoned. As discussed earlier in this book, the Bristol Art Gallery instead purchased outright around 160 works – the bulk of the loan collection – for £10,000.

As always, money values must be adjusted for inflation but opinion ever since has been divided as to who were the winners and who the losers from this transaction. For the Academy it was a crucial injection of capital at a low point in its history. The clear winners, it could be argued, were the people of Bristol, as the future of the academy had been in some doubt and today the city has two great art institutions working alongside each other, both with outstanding collections. Both the academy's and the city's collections as we know them today were actually built up later in the twentieth century, and it is not generally known that in the 1950s Bristol Art Gallery sold off at very modest prices – literally a few pounds a picture – many of the minor Victorian pictures

which they had purchased from the Academy in 1931. Much of the acquisition had become an embarrassment. Apart from the splendid Sharples collection, the only outstanding painting which they retained from that purchase was the Jordaens masterpiece.

The Academy had itself kept some works, notably Rolinda Sharples' portrait of her mother, Ellen Sharples, whose support for the original Bristol Academy had been instrumental in turning pious hopes into reality. A much later portrait of another key figure, Sir W H Wills, later Lord Winterstoke, is similarly an essential illustration of the academy's history. In the final decade of the inter-war years, the Academy's collection continued to be rebuilt, as further groups of work were acquired by gift or bequest, including paintings by such fine, but still under-rated, artists as William Matthew Hale (1837-1929), Alfred Wilde Parsons (1854-1931) and Frederick George Swaish (1879-1931). Somewhat oddly, the French artist, Jacques-Emile Blanche, who was President of the Clifton Arts Club, is also a representative of that period in the collection's history.

But the great bulk of the Permanent Collection has been acquired in the half century and more since Augusta Talboys, an artist of modest talents who specialised in cat paintings and who had been elected an associate back in 1905, bequeathed a substantial sum of money to the Academy in 1941. She had stipulated that the interest earned on the bequest should be used for the purchase of Bristol artists' work at academy exhibitions on the advice of the President and the Artists' Chairman. After legal advice had been taken, this remit was soon broadened to take in work by any RWA member, without regard to the residential qualification: without this, Bristol would not have the outstanding collection of modern British paintings that it boasts today. The earliest purchases were made in 1947, but consistent collecting began in 1951 with the resumption of exhibitions after their interruption by the war years.

An outstanding collection of paintings, drawings, prints and sculptures from the second half of the twentieth century is the result of Mrs Talboys' generosity. Happily, Lord Methuen was Academy president from 1939 to 1971 and he put in place a fastidious acquisition policy. As the Academy struggled to recover from the war and the immediate post-war years, Methuen had recognised the need, in the 1950s, to recruit distinguished artists throughout Great Britain to membership. This, with his astute buying policy,

means that the Permanent Collection includes, from that decade alone, work by artists such as Vanessa Bell and Duncan Grant, Bernard Dunstan, Henry Lamb, Anne Redpath, Claude Rogers, William Townsend, Julian Trevelyan and Carel Weight – fine representatives of what is now coming to be seen as an important period in the history of modern British art. Alongside these luminaries, distinguished artists with Bristol or west-country connections whose works were acquired in those years included Alethea Garstin (a surprisingly neglected painter, even today), Mary Fedden, Paul Feiler, Robert Hurdle, Dorothy Larcher, Lord Methuen himself, June Miles, Donald Milner, Dod Procter and the master etcher Robin Tanner.

The Talboys Bequest has benefited the Academy in other ways. The building was rewired in 1991 at a cost of £96,000 and in 1992, the Bequest funded a public sculpture competition, the commission going to Ann Christopher for her 4.5 metre high bronze, *Line from Within*, which was set up in Castle Park on permanent loan to the City of Bristol.

Bristol, and the wider art world, is fortunate to have access to a collection of work which reflects one of the major features of twentieth-century British art. Britain has quietly nurtured a remarkable wealth of very good, even outstanding, artists whose work is personal and often highly original, but which reflects a dogged adherence to a long tradition rather than any sense of obligation to innovate for the sake of innovation. Few other collections in the country cover so comprehensively this aspect of half a century of British art. As the Academy continues to grow and to enhance its facilities for managing and displaying the work it holds – to say nothing of making regular, judicious additions to the collection – the national importance of this great heritage becomes more widely appreciated.

Susan Ann, Charles Godden, pencil, 1964.

Carel Weight, CBE, RA, Adrian Daintrey, w/c, 1967.

Old Cumberland Lock, Peter Reddick, wood engraving, 1996.

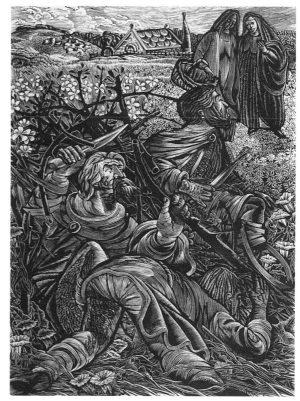

Caister Virgins 1973, George Tute, wood engraving, 1977.

The dates in these and subsequent captions indicate the year in which the work was acquired by the Academy.

First Frost, John Aldridge, oil, 1959.

Seaside Resort 1949, Evan Charlton, oil, 1986.

Near Almunecar, Spain, Sir Robin Darwin, w/c, 1969.

Green Mantlepiece, HE du Plessis, oil, 1963.

Riva Degli, Schiavoni, Venice, John Cosmo Clark, w/c, 1962.

Porthleddon, Blue, Paul Feiler, oil, 1963.

Harbour, Ian Fleming, oil, 1977.

Blue and Gold Ochre, Susan Foord, mixed media, 1997.

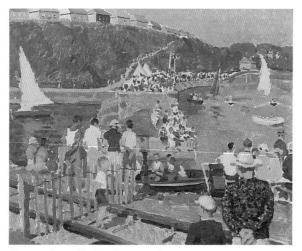

Regatta Day, Alethea Garstin, oil, 1948.

Brighton from the Beach, Judith Greenbury, w/c, 1985.

Still Life with John Dory, Duncan Grant, oil, 1966.

Provençal Landscape, Kit Gunton, oil, 1978.

The Comedian, Francis Hewlett, oil, 1997.

Summer Perspective, Plati Yalos, Anne Hicks, gouache, 1981.

Greece 1997, Kurt Jackson, collage, 1999.

Dorothea Flooded, Bert Isaac, w/c, 1994.

Welsh Farmstead, Donald Milner, oil, 1959.

Restless Zebra, Neil Murison, oil, 2000.

Flowers on a Chair, Dod Procter, oil, 1961.

Lyme Regis, March Robert Organ, oil, 1995.

The Yellow Sofa, Anne Redpath, w/c, 1960.

Sun and Burning Stubblefield,
Claude Rogers, oil, 1978.

Red Leaves, Michael Rothenstein, print, 1991.

Summer Evening, Durdham Down, Gilbert Spencer, oil, 1965.

165

River at Tenbury Wells, George Sweet, oil, 1947.

Portrait of the Artist as an Astronaut,
Nigel Temple, collage, 1991.

Avenue of the Americas, Julian Trevelyan, etching, 1984.

Almond Blossom and a Village, Jean Rees, oil.

Harbour,
William Cooper, oil.

Selected Exhibitions since 1950

The mainstay of the RWA's exhibition programme has always been the Annual Exhibition, the 150th being held in 2002. In the nineteenth century, special exhibitions including one of watercolours by Turner and a very popular showing of William Frith's celebrated painting of Paddington Railway Station helped boost flagging attendances. Two highlights in the 1930s were a remarkable exhibition in 1930 of nearly 300 Modern French paintings, drawings, sculptures and various items of applied art and, in 1937, 'Art Treasures of the West Country' which included loans of Old Master paintings from local collections.

The post-war exhibition programme started in 1946 with the 94th Annual Exhibition, held at the City Art Gallery because the Academy's galleries were still war-requisitioned. The next few decades show the Academy's galleries open to all sorts of exhibitions from the prestigious to trade shows and other special interests. Since the 1970s there has been a significant increase in the number and quality of fine art exhibitions, with the Academy initiating major shows such as those of the artists of Cornwall and of Scotland.

The following selective list of exhibitions held since 1950 will be of interest especially to students of modern British art.

indicates that a catalogue is in the Academy's archive.

1950	Seven Irish Artists*
1953	British Painters in France*
1954	Charles Rennie Mackintosh: Architecture and Drawings
	French Line Engravers of the 17th and 18th Centuries*
1955	Art in the Theatre from the 16th to 20th Centuries*
1956	20th Century Paintings from the Collection of Mr & Mrs Lawrence Ogilvie*
	Anne Redpath: Paintings*
	Lancashire Group of Artists

1958	Spring Exhibition: Paintings and Sculpture by Robert Medley, Ruskin Spear, Philip Sutton, Keith Vaughan and F E McWilliam*
	Subtopia: RIBA Travelling Exhibition
1959	Paintings and Prints by the Great Bardfield Artists Association
1962	George Melhuish: Paintings 1941-62*
1963	RWA Appeal Exhibition of Members' Work*
1964	RIBA Collection of 50 original drawings
	Paintings by R J Burn, Andrew Forge, Martin Froy and Anthony Fry*
	Lord Methuen: Recent Watercolours and Drawings*
	Shell-Mex & BP Ltd: Art in Advertising
1965	Paul Rudolph Architecture Exhibition*
	British Painting before 1940 [Arts Council]
	British Painting 1940-49 [Arts Council]
1966	Spring Exhibition: Paintings by Duncan Grant, Vanessa Bell, a memorial exhibition of Phyllis Barron and paintings by Dorothy Larcher
	Anne Redpath: Memorial Exhibition*
1970	Craftsmanship in a changing world [Crafts Council of Great Britain]
1971	John Panting: Sculpture*
	Art Spectrum South: Contemporary Art in the UK [SWA, Southern Arts Association]
	George Melhuish: Recent Paintings*
	Lord Methuen: Retrospective*
1972	Katherine Rintoul: Memorial Exhibition*
	A M Hardie: Paintings*
1974	Donald Ewart Milner: Retrospective Exhibition*

Robin Tanner Etchings: 'After Many a Summer'*

1975 'People and Landscape': Paintings by Peter Coates, Anne and Jerry Hicks*

Walter Gropius*

Robin Tanner: English Pastoral Etchings*

Wiltshire Rickyard, Robin Tanner, etching 1939/70.

1976 'Four on Tour': Peter Eveleigh, Michael Garton, John Hoyland and Paul Mount [South West Arts Touring Exhibition]

Academicians' Exhibition: Warren Storey and Four Buchanans (Norman, Lilian, Constance and David Buchanan)

Terry Frost

1977 Spring Exhibition: Ian Black, Colin Gifford, June Miles and George Tute*

Sybil Mullen Glover: Paintings*

1978 Two Artists Look at Antarctica – Another World: David Smith and Edwin Mickleburgh

William Townsend: Retrospective*

56 Group Wales: Paintings and Sculpture*

Peter Lanyon

1979 Spring Exhibition: inc. Reg Gammon, Jean Du Maurier, Dan Burden and Neil Murison*

Kellogg National Children's Art Exhibition*

Gerald Scott: Drawings, Sculpture, Etchings

Drawn from Nature: AS Hartrick, TB Hennell and Vincent Lines

1980 New Year Exhibition: Derek Balmer, Gerald Cains, Denys Delhanty, Kate Delhanty, John Hussey and John Stops

British Art Show [Arts Council]

Margaret Norman and Alan Lowndes

South Wales Potters*

1981 Paintings, Drawings, Sculpture, Collages: John Codner, Le Clerc Fowle, Margaret Lovell, Richard Macdonald, Nigel Temple, Peter Thursby

Peggy Trotman

| 1982 | Spring Exhibition: Six Artist Members – Diana Armfield, Rodney Burn, John Flavin, Morris Kestelman, Anita Mandl, Alastair Michie |

Ernst Blensdorf: Sculpture

Cadbury National Exhibition of Children's Art

A E (Hamish) Milne RWA

1983 Jane Pascoe and Roy Clapp

1984 Recent Paintings and Watercolours by Leslie Goodwin RWA and Kathleen Crow AROI*

Restoration of the House of Lords Chamber Ceiling, Palace of Westminster* [West of England Restoration Studio]

Peter Potworowski [Polish Government/University of London Institute of Education]

1985 Stanislaw Frenkiel, Alfred Harris and Bert Isaac

Louie Burrell

Reg Gammon: Retrospective*

'Art from Industry': Exhibition of paintings owned by local industry*

1986 Spring Exhibition: Five Artist Members – Anthony Eyton, Peter Folkes, Jean Rees, Warren Storey and Julian Trevelyan*

Royal Institute of Painters Exhibition*

Evan and Felicity Charlton

David Blackwood: Etchings

1987 Cadbury National Exhibition of Children's Art*

Jack Chalker: 'Images of War' drawings and paintings from a POW Camp in Thailand

Jane Lewis: Artist in Residence, Kent Opera Company

Hon RWA Members: Elizabeth Blackadder, Olwin Bowey, Sir Hugh Casson, Elisabeth Frink, Roger de Grey, Flavia Irwin, Leonard Rosoman and Carel Weight

1988 RT Cowern: Retrospective Exhibition of Etchings and Watercolours

Five Academicians: William Cooper, Bernard Dunstan, Mary Fedden, Judith Greenbury, Leonard Manasseh

Open Printmaking Exhibition*

Sidney Nolan: Paintings 1937-87* [Spicer Oppenheim and SWA]

1989 The Glory of Watercolour*

Lord Methuen*

Royal Society of British Sculptors

Frank Bowling

UK/US Print Exhibition*

Council of the RWA and Three Past Presidents

1990 42nd National Exhibition of Children's Art*

Spring Exhibition: Royal Watercolour Society*

Contemporary Poets: Paintings by Peter Edwards* [National Portrait Gallery]

1991 Second Open Printmaking Exhibition*

Scottish Art in the 20th Century*

1992 Denis Reed*

Triple Guard, William Gear, oil, 1988.

Mavericks: Unlikely Works by Royal Academicians* [touring from RA, London]

Paintings by Polish artist Caziel*

Artists of Russia: A New Generation [Debbie Hatchwell Fine Art Consultancy, London]

Cartoons by Nicholas Bentley, H M Bateman and others

Nine Artist Members: Nigel Casseldine, Dawn Sidoli, Margaret Thomas, Alastair Flattely, Ken Oliver, Rita Greig, Ann Christopher, Elisabeth Frink*

Artists from Cornwall*

The Royal Institute of Painters in Water-colours*

Alan Davie: Retrospective

1993 Claude Rogers: Retrospective

Anthony Whishaw: Retrospective

56 Group Wales*

Degree Show: University of Plymouth, incorporating Exeter and Taunton

First Open Sculpture Exhibition*

1994 Early Paintings from the Permanent Collection

National Westminster Bank Life Sculpture Exhibition

Reg Gammon: A Celebration of 100 Years*

Open Print Exhibition*

Gwen and Fred Whicker [Falmouth Art Gallery touring exhibition]

Joan Miro – small touring print exhibition [Arts Council]

William Tillyer: Oil Paintings*

President's Choice: architectural work selected by Leonard Manasseh*

Polish Roots-British Soil*

Picasso Etchings – small touring print exhibition [Arts Council]

National Westminster Bank Contemporary Art Collection (art from 1970s-1990s)*

1995 RWA Permanent Collection: Years of Growth 1945-1970*

The President's Exhibition*

Ben Uri and Bernard Cohen drawings*

Seven Academicians: Christopher Glanville, Sheila Tolley, Ken Howard, Robert Organ, Anthony Curtis, Lucy Willis, John Taulbut*

Penwith Society of St Ives and Bryan Pearce Retrospective*

150th Anniversary of RWA in London: Bruton Street Galleries*

John Dodgson (1890-1969) [Fine Art Society touring exhibition]

Robert Hurdle: Retrospective*

Hans Scharoun (1893-1972): touring architecture exhibition

Bryan Kneale: Retrospective

Donald Milner (1898-1993): watercolours, drawings and paintings

1996 RWA Permanent Collection

Bernard Dunstan: Aspects of The Royal Academy, lithographs [touring exhibition]

Susan Macfarlane: 'A Picture of Health'* [touring exhibition from The Barbican]

Ray Atkins

Kurt Jackson*

Second Open Sculpture Exhibition*

1997 Arthur Bell (1897-1995): Memorial Exhibition*

RWA Permanent Collection: Paintings purchased by the Talboys Bequest*

Fourth Open Print Exhibition*

'Exploration': Paintings by Bristol Schoolchildren to commemorate John Cabot

Six Academicians: Paintings and Sculpture by June Berry, PJ Crook, Francis Hewlett, John Huggins, Alfred Stockham and George Tute

The Pastel Society*

Roger De Grey*

1998 RWA Permanent Collection*

Barrington Tabb*

Michael Kenny RA*

RWA Academician Works: Current Members' Work*

Robert Hurdle at 80*

Maurice Cockrill: Recent Paintings*

1999 Julian Trevelyan

Paintings by Robert Jennison and Diana Sylvester, sculpture by Andrew Stonyer

Michael Porter

Six Art Colleges: Bath Spa University; University of Wales Institute, Cardiff; Cheltenham and Gloucester College of Higher Education; Falmouth College of Arts; University of Plymouth, Exeter; University of the West of England, Bristol*

Six Academicians: Camilla Nock, Stewart Geddes, Susan Caines, Susan Foord, Ann Christopher works on paper and John Maine sculpture

Third Triennial Open Sculpture Exhibition (selection by John Maine and Alison Wilding)*

Red Labyrinth, Maurice Cockrill, oil, 1997.

Albert Irvin: Paintings and Prints

2000 Sonia Lawson and Neil Murison, and selected works from the Autumn
 Exhibition

 Open Print Exhibition

 Richard Long

 Royal Society of Portrait Painters

 Peter Prendergast

2001 Martyn Brewster, Six Academicians: Gerald Cains, Denys Delhanty,
 Kate Delhanty, Jennifer Harris, Stuart Jennings and John Stops

 Terry Setch

 West by South West: a collaboration of distinguished Norwegian and
 British artists, sharing images of landscape

 The Academy: selected still-life paintings from the RWA Permanent
 Collection

2002 Exhibition programme interrupted by building works, resuming with
 150th Autumn Exhibition in October

 An exhibition of Academicians' work, 'All at Sea', was held at @t Bristol

In addition to the Academy's annual exhibitions, other exhibitions in this period
included work from the College of Art, the School of Architecture and Clifton Arts Club.

River Avon Mud Circle,
Richard Long, Malmö, 1985.

Friends of the RWA

Organised supporters are important to the life of countless arts institutions. RWA Friends provide practical, financial and moral support for the Academy, with a broad programme of activities, and form a link between the artists and a wider public.

For many years from the foundation of the Academy, the influential and generous patrons, known as 'Subscribers', were central to its maintenance and administration. Although Lord Methuen shifted control to artist members during his presidency (1939-71), the value of Subscriber members continued to be recognised. The term was still in use when Mary Fedden, president from 1984 to 1989, asked Warren Storey to provide a programme of events to include outings and lectures, which he continued with little help for several years.

In 1990, during the presidency of Leonard Manasseh, the title of 'Subscribers' was changed to 'Friends', and Gwyneth Browne successfully organised a programme of events. The Council invited the Friends to form a committee which was elected at their first AGM in 1993 with Ann Fawcett as Chairman. Subscriptions were collected by the Academy and funds were allocated to Friends.

The Friends Committee saw that there was much potential and much that could be done to further the interests of the RWA. The specific aims, outlined in the constitution, were to raise funds for the RWA, to support and co-operate with the Academy in promoting knowledge and appreciation of the visual arts and to provide a focal point, range of educational programmes and other events.

Established voluntary help in entertaining visitors, stewarding of galleries, portering and so on was expanded to include new activities. Lectures with buffet lunch, an essential part of the RWA's educational programme, were started in 1992 and have since grown to a full annual programme. Later innovations included occasional evening lectures and painting workshops. The holiday and day trip programme grew to cover visits by coach to museums and galleries and cultural and painting holidays in Britain and abroad. In 1997 the then President, Peter Thursby, encouraged exhibitions of Friends' art and photography, which proved popular and successful. Other activities included manning a Friends Desk and the sale of Christmas cards.

The Friends newsletter grew from a single page in 1993 to an elegant magazine printed three times a year, partly funded by advertising revenue. In 1998 colour pages were introduced at the request of the Council to help publicize the launch of the Millennium Appeal. The contribution of a magazine proved a valuable asset and mouthpiece for both the Academy and the Friends.

Friends' Chairman, Roland Harmer, hands a substantial cheque to Academy President Derek Balmer.

During Robert Huddleston's chairmanship from 1997 to 1999 the last phase of reorganisation took place with a revised constitution and the Friends taking over from the Academy the collection of subscriptions with the help of a computer and database. Later a paid membership secretary was appointed. Close ties were maintained with the Academy, with a Friends' observer present at Council meetings. Roland Harmer became chairman in 1999, instituting a system of sub-committees to deal with specific tasks, such as holidays and day trips, designed to draw more people into the committee's work and to streamline decision-making.

The enterprise shown by the Friends, and the immense efforts of many voluntary helpers, have been of great benefit to the Academy which each year has received an increasing sum of money for the RWA and for the Appeal. In 2001 the amount was an impressive £15,500.

The Friends have always welcomed new faces, with membership offering many privileges and opportunities to meet other people with an interest in the visual arts. The membership secretary can be contacted at the Academy's offices.

Presents of the Academy

1844-1859	John Scandrett Harford
1859-1881	Philip William Skynner Miles, MP
1881-1884	Samuel Lang
1885-1887	Colonel HBO Savile
1887-1897	Daniel Charles Addington Cave
1897-1898	Alderman Francis J Fry
1898-1911	Sir William Henry Wills, Bt. (Lord Winterstoke)
1911-1932	Dame Janet Stancomb Wills
1932-1936	Mrs Yda Richardson
1939-1971	Paul Aysford Methuen (Lord Methuen), RA, RWA
1972-1973	Sir Robin Darwin, CBE, ARA, D Litt
1974-1979	Donald Ewart Milner, OBE, MA, RWA, ARCA
1979-1984	Bernard Dunstan, RA, RWA
1984-1988	Mary Fedden, RA, RWA, DFA (Lond)
1989-1994	Leonard Manasseh, OBE, RA, FRIBA, RWA
1995-2000	Peter Thursby, RWA, FRBS, D Art (Hon)
2001-	Derek Balmer, RWA, D Art (Hon)

Artists'/Academicians' Chairmen

1844-1861	William West
1862-1878	J Jackson Curnock
1879-1890	Robert Taylor
1890-1892	Lawford Huxtable
1892-1894	Samuel Phillips Jackson, RWS
1894-1897	H Morley Park
1898-1909	Henry Dare Bryan
1910-1920	FAWT Armstrong, RBA
1921-1933	n/a
1934-1946	Charles Frederick William Dening, RWA
1946-1967	Paul Aysford Methuen (Lord Methuen), RA, RWA, LLD (Hon)
1967-1973	Donald Ewart Milner, OBE, ARCA, RWA, MA
1973-1976	Ernest Pascoe, FRBS, RWA
1977-1980	Gerald AW Hicks, MBE, RWA
1980-1982	John Hussey, ARBS, RWA
1983	Warren Storey, RWA
1984-1987	Peter Thursby, RWA, FRBS
1987-1989	Kenneth Oliver, RWA
1990-1993	Jean Rees, RWA
1994-1996	William A Cooper, MA, RWA
1997-2000	Derek Balmer, RWA
2001-	John Huggins, RWA, FRBS

Honorary Treasurers of the Academy

1844-1858	George H Ames
1858-1874	Not known
1874	St. Vincent Lines
1875	George Bright
1877-*c.*1879	M Rixeley (Salaried)
1880-1882	L Vincent Lines
1882-1917	Sir Charles D Cave, Bt.
1917-1925	Melville Wills
1925-1930	F Burris, JP
1931-1950	P V Roberts
1950-1964	G O Canning
1964-1970	A L Rowell, DSO, FCA, Hon RWA
1971-1984	P D Lace, FCA
1984-1995	John A Gunn, BA, FCA
1995-1997	David Peakall, FCA
1997-	Peter Stoppard, FCA, Hon RWA

Honorary Secretaries & Secretaries of the Academy

1844-1856	Jere Hill
1856-1874	G Elsey
1875-1876	George Bright
1876-1885	Fenton Miles
1885-1887	Daniel C A Cave
1889-1897	Robert Hall Warren
1897-1910	Richard Clapton Tuckett, LL B
1910-1917	Ralph Lewin
1917-1918	F A W T Armstrong (acting)
1918-1919	Percy Baldwin
1920-1923	W H Salisbury
1924-1946	C F W Dening, RWA
1946-1950	H W Maxwell (acting)
1950-1967	Donald Ewart Milner, OBE, ARCA, RWA, MA Miss Aileen L Stone (Organising Secretary) 1950-1974
1968-1975	George Sweet, RWA Miss Jean McKinney, MBE (Organising Secretary) 1975-1995
1975-1978	Gerald Scott, RWA
1978-1983	Ian Black, RWA
1984-1986	Denys Delhanty, RWA
1986-1987	Gerald Cairns, RWA
1988-1994	Peter Thursby, RWA, FRBS

1995-1997 Pamela J Crook, RWA
Miss Rachel Fear (Academy Secretary) 1996-2002

1998-2000 John Huggins, RWA, FRBS

2001- Professor Andrew Stonyer, Ph D, RWA

Bibliography

Art on the Line: The Royal Academy Exhibitions at Somerset House 1780-1836,
ed. David H Solkin, Yale University Press, 2001

Bristol: An Architectural History, Gomme, Jenner, Little, Lund Humphries, 1979

Bristol Art Gallery 1905-1980, Karin Walton, Bristol Museum & Art Gallery, 1980

The Bristol Landscape: The Watercolours of Samuel Jackson 1794-1869,
Francis Greenacre and Sheena Stoddard, City of Bristol Museum & Art Gallery, 1986

Bristol: Last Age of the Merchant Princes, Timothy Mowl, Millstream Books, 1991

The Bristol School of Artists: Francis Danby and Painting in Bristol 1810-1840,
exhibition catalogue, Francis Greenacre, Bristol City Art Gallery, 1973

Catalogue of the Sharples Collection, Richard Quick, Bristol Art Gallery, 1910

A Chronicle of Clifton and Hotwells, Helen Reid, Redcliffe Press, 1992

City Impressions: Bristol etchers 1910-1935, Sheena Stoddard, Redcliffe Press, 1990

Diaries of Ellen and Rolinda Sharples, 1803-36, unpublished MSS, Bristol Central
Reference Library; typescript in Bristol Museums & Art Gallery.

Dictionary of Artists in Britain since 1945, David Buckman, Art Dictionaries Ltd, 1998

'Ellen and Rolinda Sharples: Mother and Daughter Painters', Kathryn Metz,
Woman's Art Journal, Vol.16, no.1, 1995, pp.3-11

An English Journey, JB Priestley, William Heinemann Ltd., 1934

An Essay in Patronage, Donald Milner, RWA, 1975

Furnished with Ability: The Lives and Times of Wills Families, S J Watson,
Michael Russell (Publishing) Ltd., 1991

The Houses of Parliament, M H Port, 1976

A Northern School, Peter Davies, Redcliffe Press, 1989

Open Doors: Bristol's Hidden Interiors, Stephen Morris and Timothy Mowl,
Redcliffe Press, 2002

A Painter Laureate: Lamorna Birch and his circle, Austin Wormleighton,
Sansom & Company, 1997

St Mary Redcliffe: an architectural history, Michael Q Smith, Redcliffe Press, 1993

Sculpture in Bristol, Douglas Merritt, Redcliffe Press, 2002

The Sharples: Their Portraits of George Washington and His Contemporaries,
Katharine McCook Knox, Yale University Press, 1930

Mrs Sharples Letters, 1840-*c*1845, unpublished MSS, Bristol Central Reference
Library; typescript in Bristol Museums & Art Gallery.

George Sweet: Painter, Teacher and Friend, Judith Greenbury,
Sansom & Company, 1998

To Build the Second City: Architects and craftsmen of Georgian Bristol,
Timothy Mowl, Redcliffe Press, 1991

Victorian Buildings in Bristol, Clare Crick, Redcliffe Press, 1976

The Walter Crane Lunettes at the Royal West of England Academy, Anthony Crane,
RWA Publications, 1995

WD & HO Wills and the development of the UK tobacco industry 1786-1965, B W E
Alford, Methuen & Co, 1973

The lives of the Sharples family were thoroughly researched by Katharine McCook Knox
and published in 1930. Her searches of archives and collections on both sides of the
Atlantic have not been superseded and any account of the family is much indebted to her
book; no new information on the early lives of James senior or Ellen has subsequently
emerged.

There is also much information in the files of the Fine Art office of Bristol Museums &
Art Gallery, compiled by past curators, and it would not have been possible to write
the Sharples essay without them.

Index

[See also: Selected Exhibitions and List of Academy officers]

Page numbers in **bold** relate to illustrations or captions.